COLWYN BAY
in the 1950s
Ten Years that Changed a Town

COLWYN BAY
in the 1950s
Ten Years that Changed a Town

GRAHAM ROBERTS

AMBERLEY

For Daphne,
A lovely lady and a child of the fifties

First published 2014

Amberley Publishing
The Hill, Stroud
Gloucestershire, GL5 4EP

www.amberley-books.com

British Library Cataloguing in Publication Data.
A catalogue record for this book is available from the British Library.

ISBN 978 1 4456 4048 8 (print)
ISBN 978 1 4456 4080 8 (ebook)

Typesetting and Origination by Amberley Publishing.
Printed in the UK.

CONTENTS

INTRODUCTION

Like every other town in Great Britain, Colwyn Bay spent the 1950s shaking off the effects and austerity that were the legacy of the Second World War. It was a decade in which people licked their wounds, tightened their belts and counted the cost. Colwyn Bay, however, had been affected by the war in a very special way and, to a certain degree, in the 1950s the optimism generated in other towns around the country was not necessarily mirrored by that shown in Colwyn Bay.

As I demonstrated in my book *Colwyn Bay At War*, Colwyn Bay had had a wonderful war; no bombs had fallen on the town, all the cinemas and the pier pavilion had been open for business, all the shops did a roaring trade, the schools were full to bursting and everyone enjoyed a bustling social life. This was all made possible by the fact that for the duration of the war, the town was essentially requisitioned by the Ministry of Food. The 5,000 civil servants who had arrived from London, and the local population, were all united in the worthy occupation of making sure that the people of these islands did not starve while Hitler remained alive.

Once the war was over, and the Ministry of Food decamped back to Guildford, Colwyn Bay had to readjust to the loss of its former glorious role in the life of the country, and come to terms with the austerity of the 1950s. Colwyn Bay reverted to its pre-war role as a holiday resort, but these years were the last hurrah for the seaside holiday before the advent of the foreign holiday. The Health Department of the council reminded people about the healthy properties of the local mild, dry climate. Colwyn Bay struggled throughout the fifties, trying to find a new role for the town. The shops changed and new businesses opened up on the outskirts of the town; the promenade, and especially the pier, continued to be a focal point of the social life of the area and though the cinemas were open, they declined in number. An indication of a changing world was the vigorous attack on the anti-drink activities of the Free Churches at the 1951 annual dinner of Colwyn's Licensed Victuallers Association by John Lees Jones who said that the churches could start talking when they had a few more people through their own doors, and upstanding publicans should not be 'spied on and reported for every slight breach of the law'. The 1950s in Colwyn Bay, as elsewhere in the country, were witness to the first indications of the general erosion of respect for authority. The people of Colwyn Bay were realising that they now lived in a world

where individuals were free to make their own decisions and mistakes, and that this freedom could have serious consequences. I once spied a sticker on the bumper of an American car: 'What if the Hokey-Cokey is what it's all about?' In the 1950s the people of Colwyn Bay discovered that there was more to life than that, but, on the whole, they were comfortable years. A new and innovative help to the social interaction of the town was the founding of Colwyn Bay Round Table in October 1955. The town's librarian, Mr Ifor Davies, described by the town clerk, Geoffrey Edwards, as 'a merry man', told the Town Council Library Committee that the provision of some kind of floral decoration, suitably arranged on a pedestal or like bowl, would be an asset to the library.

Slowly, with new prosperity, cars started to clog up the road system, which would eventually result in the building of a dual carriageway smack through the middle of the town in the 1970s. Being on the coast, and of no strategic value to the Germans, no bombs had fallen on Colwyn Bay during the war; there was no necessity to redevelop the town, but slowly old buildings were pulled down and replaced with more up-to-date versions. For Colwyn Bay the fifties were invigorating, a wakeup call to the realities of the changed world after the chaos of the 1940s. This decade proved, for the people of Colwyn Bay, that the secret to a happy life is not, as Cicero urged, freedom from care, but a sense of purpose.

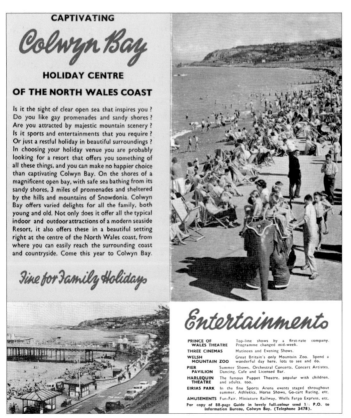

From a 1950s brochure.

1

THE PROMENADE

In a 1950s brochure promoting Colwyn Bay, the promenade is described as 'Three miles of Fascination'. Included in the text is the sentence, 'A walk along the lovely promenade is one of the finest attractions of captivating Colwyn Bay.' The councillors of the Borough of Colwyn Bay were quite rightly determined to promote the benefits of the promenade to the large contingents of holidaymakers who, in the 1950s, still descended on this town in their hordes during the summer months. The brochure described the promenade as being 'bordered by golden sands, washed by the sea, in summer time it is alive with colour and gaiety'. The only lighting on the promenade was from ornate decorated columns, which had been in use since the promenade was opened in 1898, and from strings of lightbulbs hung between the columns. In the summer there was a run-about-bus, which was driven constantly up and down the road beside the promenade, from the Old Colwyn end to Rhos-on-Sea. There was also a mechanical elephant, which was driven along the promenade by the walking driver, who idled along beside the elephant and worked the beast from a handle inside the elephant's ear; eight children, along with the fire extinguisher, could be accommodated on the seat on the top of the beast. You could have been 'snapped' and, for a few shillings, offered the processed photograph the following morning. There was Mr Codman's Punch and Judy show, which always attracted an enormous crowd of children and, in a less sophisticated age, a good number of happy adults. A miniature railway, which opened on 29 June 1953, chuffed and hooted its way along what is now the footpath between the Eirias Park entrance and the railway bridge opposite the pier. Mr Lee, then known – affectionately, though it would now be considered either racist or unkind – as 'Darky' Lee, opened his wooden shed across the road from the pier, where he hired out deckchairs and sold fishing bait and other bits. There were constant beauty contests, sandcastle building competitions and diving displays from the three rickety wooden towers standing in the sea, one beside the pier, one opposite the Colwyn Bay Hotel and the other in the sea opposite the Cayley Pub in Rhos-on-Sea. Two young lads, Ken Lloyd, and a future magistrate, Gwilym Davies, sat on top of the tower beside the pier for four hours waiting for the tide to come in; when they were eventually surrounded by the sea, they were too nervous to dive off and had to be rescued. Gwilym went home and was boxed around his ears by his mother.

On Coronation Day, 2 June 1953, a 21-gun salute was fired from the promenade by artillerymen stationed at Kinmel Camp. On the first Monday in August of that year all 7,000 deck chairs available for hire on the promenade were taken by the early afternoon.

The Promenade was a message to the wider world that Colwyn Bay was once again open to the people of Great Britain after the ravages of the war years. Not only that, but this stretch of the coastline reminded people how life had been before the conflict began. It was reassuring. It is a promenade for the easygoing, relaxed, little-stressed person, who is looking for a golden beach without the hectoring nuisance of a garrulous vendor selling stuff no one wants. In the 1950s, and still today, people walked along the promenade to relive a more gentle age.

It is believed that, had the Victorians not constructed the Colwyn Bay Promenade, the sea would now be lapping at the bottom of Station Road. This danger was confirmed when, in 1954, a ferocious storm undermined a section of the sea wall near to the Eirias Park entrance. The Victorians preserved the Prom for the civil servants of the Ministry of Food during the Second World War, for the happy holidaymakers of the 1950s and for us today. As another 1950s brochure revealed, 'The Promenade has endless attractions. At gay Rhos-on-Sea, Water Ski-ing, Par-Putting, a big Paddling Pool, and the magic of Britain's only permanent Puppet Theatre.' And it is all still there.

The grandest building alongside the Promenade, and indeed in the whole of the town, was the Colwyn Bay Hotel. During the war, it became the national headquarters for the Ministry of Food, but eventually, by 1952, all the civil servants had vacated the building and it was ready to reopen as a hotel once again. The owner, Mr Ambrose Quellyn Roberts, asked Sydney Colwyn Foulkes and his son, Ralph, to redesign and refurbish the interior of the hotel after the havoc caused within by the civil servants. He requested that they design a stepped walkway straight off the promenade into the hotel bar; sadly, this idea was subsequently dropped.

Opposite above: The promenade at the Rhos-on-Sea end in the 1950s. The railway line goes through the picture (with the smoke of a train to the left of the picture), taken before the construction of the A55 road, which now runs alongside the railway line. Penrhos College and playing fiends are visible in the centre of the picture, with Daniel Allen's Depository, the army barracks and Hollingdrakes Garage, now all gone, ranged along the lower side of the railway track on Princes Drive. Conwy Road is the main road in the bottom left-hand corner. The sale of Penrhos College made way for the construction of a housing estate, and town houses were built where the barracks once stood; the garage and depository made way for the new road.

Opposite below: The mechanical elephant was owned by Colwyn Bay Council and all the profits went into the local public purse. It didn't actually go very far but was much appreciated by children unused to public displays of enjoyment. On the quiet days – which were usually the 'change-over days' for visitors, Saturday – one of the enterprising young drivers, Tom, would take the elephant to the railway station and inveigle the newly arriving holidaymakers, for a small charge, into taking this unusual form of transport to their hotel or boarding house. He had to stop this enterprise when he was spotted by Johnnie Neal, the council entertainment officer.

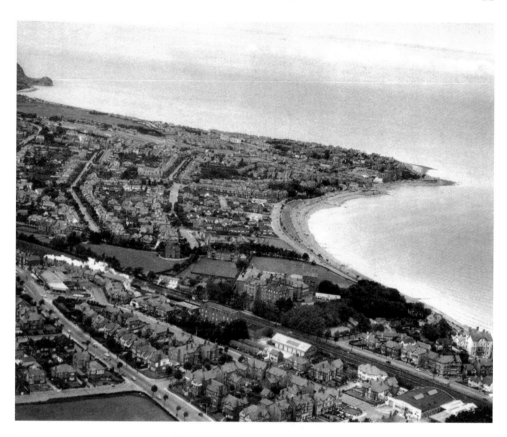

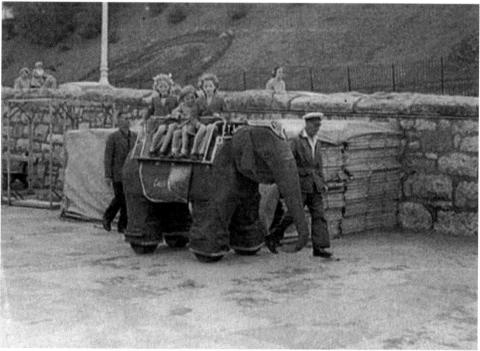

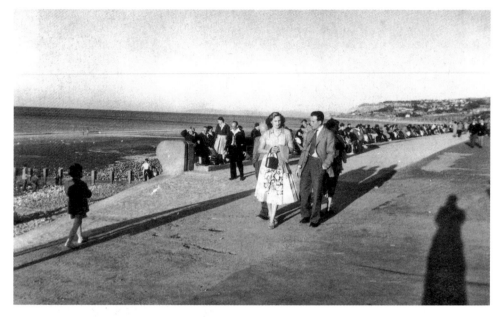

In 1954, a new sea wall was built, which incorporated benches in its design. They became a popular feature of this stretch of the Prom. Now, sixty years later, the wall has been demolished to make way for improvements.

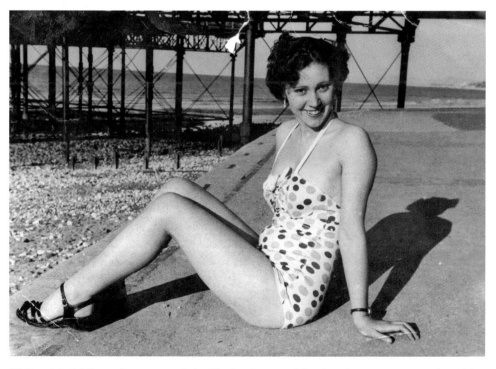

Jill Baugh in 1951, on the promenade beside the pier, practising for a beauty contest and catching the eye of a local postman, Joe Davies, whom she married when she was twenty-one.

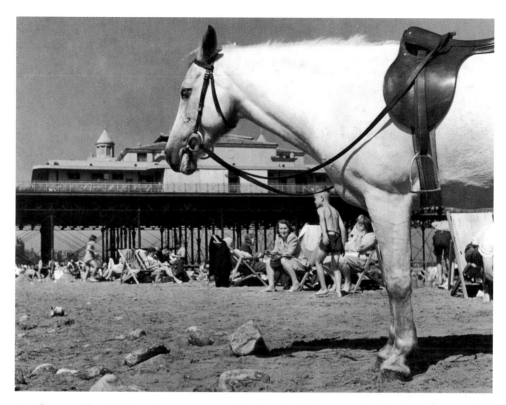

Another world; a 1950s summer scene, waiting for the tide to come in. No more wars, safe as safe can be in a free world.

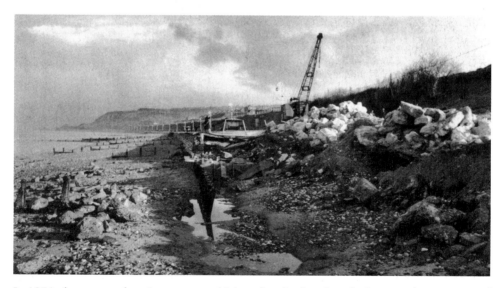

In 1954, there was a ferocious storm, which undermined and washed away a large section of the sea wall and promenade near to the Eirias Park entrance. Work started immediately after the storm to repair the damage, as there was a chance that more of the promenade would be reclaimed by the sea in any subsequent storm.

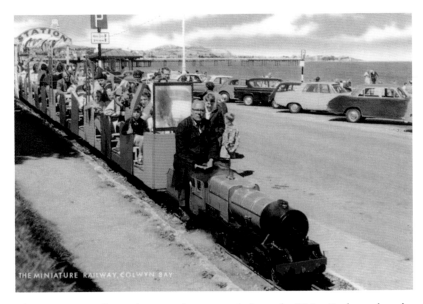

The miniature railway that ran along a track from the Eirias Park road to the tunnel opposite the pier. The driver, as can be seen in the photograph, always wore his tie and his Sunday shoes and trousers.

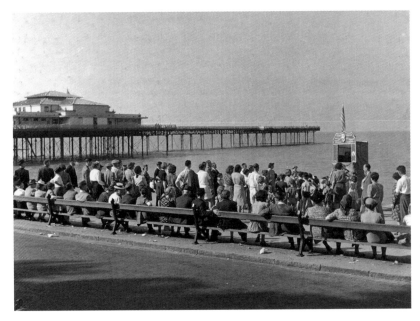

Mr Albert Codman's Punch and Judy show was a regular and popular feature of the promenade during the fifties. He would put on about five shows each summer's day; the clock on the right-hand side of the stage announced when the next show would be held. The flag on the top of the stage is the American flag, which Mr Codman liked to fly to show his appreciation of the help we received from America during the war.

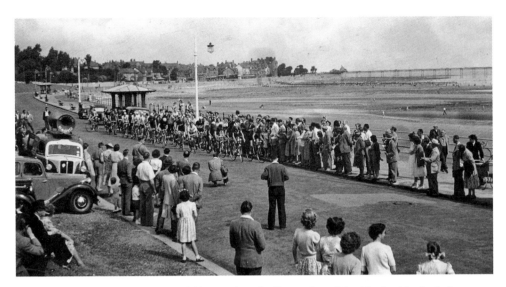

This section of the promenade could be cordoned off at each end, beside the Aberhod slipway at the Rhos end and below Penrhos College at the other, allowing traffic to run unhindered along the 'Upper' Promenade. This freed the prom to be used for races, car rallies and for film festival celebrities to judge beauty contests. The picture shows the start of 100km Road Cycle Race in August 1950.

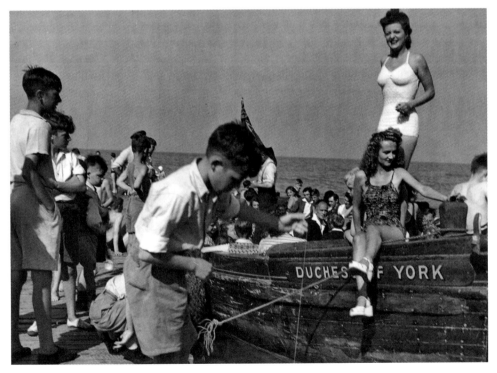

What a commotion two young girls can make on a summer's afternoon. The *Duchess of York* was a boat on which the paying public could go for a sail around the bay. All the boys have the same clothes and the same haircuts, and the two ladies have the regulation 1950s hair styles.

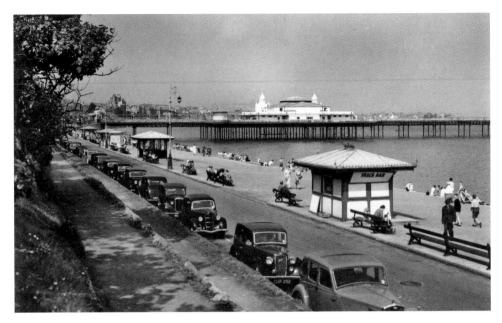

The Prom showing the variety of colours used for cars; black and light-black.

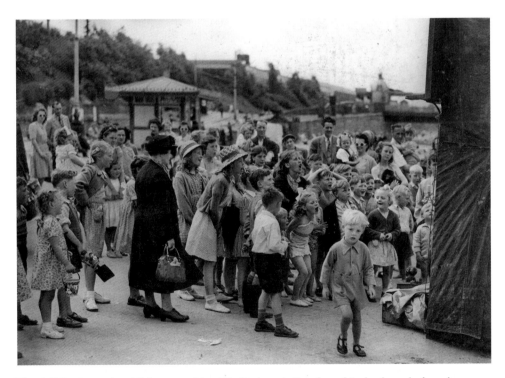

The delight shown by children watching Mr Codman's Punch and Judy show, before there was a television in every home and before all young eyes were downcast, concentrating on their iPhones. The picture also shows the contrast in clothing between the children growing up in the 1950s and the older lady, dressed from head to foot in black, with sensible shoes and floral hat.

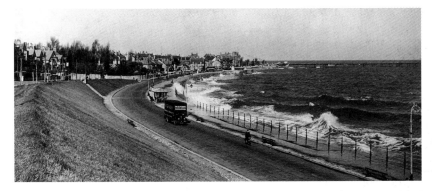

A more or less deserted promenade at the Rhos-on-Sea end, showing a Pickford's removal lorry in hot pursuit of a lone female cyclist. Rhos-on-Sea Pier, which was demolished in 1954, can be seen in the background. Also visible are the wonderfully ornate lamp posts and shelters, which have all been replaced by inferior products.

Above and below: Two typical Rhos-on-Sea Promenade scenes of the 1950s, tranquil and peopled by well-dressed strollers. In the picture below, the two buildings on the immediate left have been demolished and have made way for flats. In the picture below, the shelters have been replaced with ones of an inferior and less appealing design.

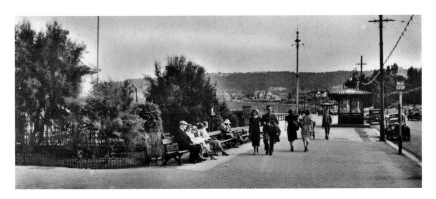

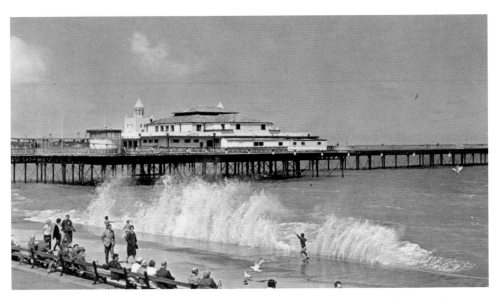

The pier and promenade on a balmy summer's day in the fifties, with all the men dressed in jackets and ties. It was still a buttoned-up age, before the explosion of the swinging sixties.

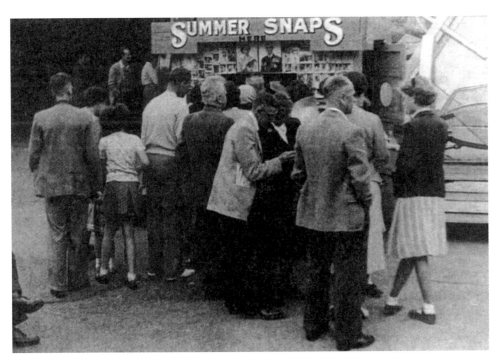

The very first promenade kiosk was the Summer Snaps kiosk, where Mr Mack ran a quick service summer portrait business. His employees would stroll along the promenade snapping, paparazzi style, anyone they felt could afford, and would want, a holiday photograph of themselves. These people would then be handed a numbered ticket and told that if they turned up the following morning at Mr Mack's kiosk, they could collect their photograph for a small charge.

The Colwyn Bay Hotel, now demolished, dominated the promenade and served as the meeting place for civic lunches, Round Table meetings, wedding receptions, and all sorts of other grand Colwyn Bay occasions.

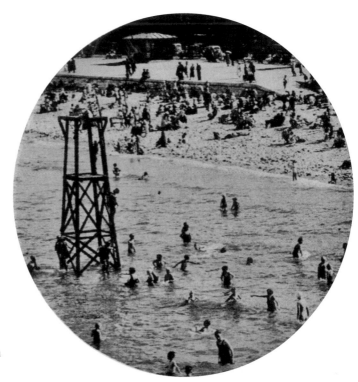

The wooden diving tower beside the Colwyn Bay Pier in 1951.

2

THE PIER PAVILION

During the fifties, one of the most important council committees was the Pier, Promenade & Entertainments Committee. It was in the Pier Pavilion that most of the town's live entertainment took place. In May 1954, the Conference of the National British Women's Total Abstinence Union was held in the pavilion and it was the meeting place for the Colwyn Bay Rotary Club's annual general meeting. Many of the local schools used the pavilion for their yearly prize-giving ceremonies and, each year, Rydal School used the facilities to produce their school play. However, these years were the swansong for variety entertainment on the pier; the most successful enterprise in the pavilion towards the end of the fifties were the Sunday evening concerts, timed to start half-an-hour after the end of church services, with the Municipal Orchestra under Mr Charles Haberreiter. The nineteen Sunday concerts in the 1959 season attracted over 8,000 people. The dwindling audiences, who began to stay at home to watch their small black and white television sets, and the dwindling numbers of holidaymakers, made the variety show on the pier too expensive.

Opposite above: A carefree summer's crowd on the pier outside the pavilion, where in the afternoon you could listen to the residence orchestra playing on the bandstand, off to the right of the picture.

Opposite below: The Pavilion in the heady days of the early fifties.

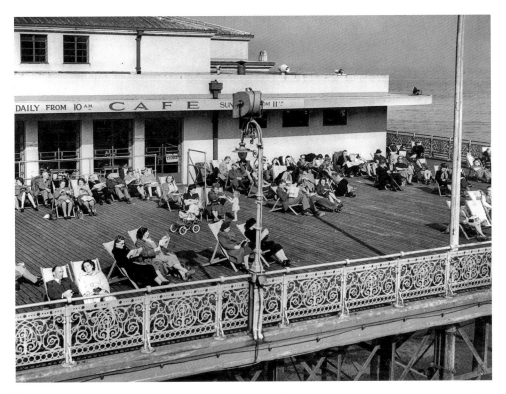

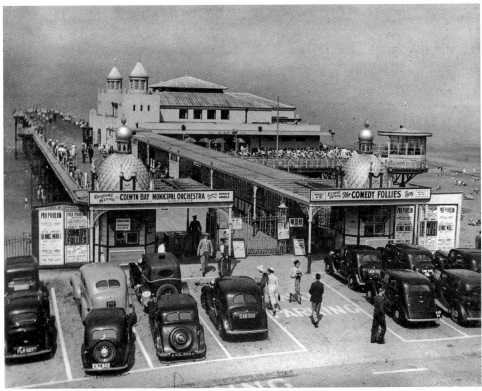

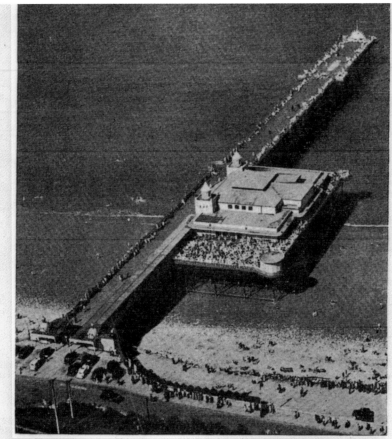

PIER PAVILION

COLWYN BAY

Manager (for the Corporation) J. E. NEAL
Telephone: 2594 Box-office 2689

★ ★ ALL STAR ★ ★	DAILY CONCERTS
HOLIDAY SHOW	*by the*
★	**MUNICIPAL ORCHESTRA**
NIGHTLY at 7.45	*Directed by* CHARLES HABERREITER

SUNDAYS AT 8 p.m.

CELEBRITY CONCERTS

May to September **DANCING**	**CAFE** Open daily from 10 a.m. to 6 p.m.	**Fully Licensed SALOON BAR** Open during Licensed Hours

From a 1952 Colwyn Bay brochure.

3

TRANSPORT

In 1951, my sister and I walked, unaccompanied by our parents, from Rhos-on-Sea to Conway Road Primary School in the west end of the town. There was no roundabout at 'five-ways', where Ebberston Roads East and West, Brompton Avenue, Whitehall Road and Broadway all meet each other, and where we safely ran across the junction; very few cars trundled along these roads and invariably, if one did, the driver would toot his horn and wave to us. It was only six years since the war in Europe had come to an end when Braid Brothers, the garage on Conway Road, had been used to build hundreds of vehicles for the Allied Forces during the conflict; in the 1950s, only a handful of cars were being constructed for the domestic market. Yet, unusually, there was a plethora of garages in Colwyn Bay. To a certain degree, this was an indication that the town had become home to an increasing number of retired, affluent people who had been fortunate to be living in a safe area during the war and had survived intact, and also a sizeable number of former Ministry of Food civil servants, who had decided to remain in Colwyn Bay after the war, instead of returning to the hurly-burly of Guildford.

The trams were running an efficient and regular service; in 1954 the line carried 2.7 million passengers. There was an intermittent bus service, a few private and unregulated taxi drivers, an ever-increasing number of private car owners, all with small, black vehicles, and a surprising number of chauffeur-driven cars. Rhos County Garage, Berry's Garage (tucked away between Everard Road and Brompton Avenue), Hancock's service station on Penrhyn Avenue and Penrhyn service station on Church Drive serviced the cars in Rhos-on-Sea; Hollingdrakes and Chester Engineering, which were both on Princes Drive in Colwyn Bay, the two Braid Brother garages – the one on Abergele Road (now Stermat) and the one on Conway Road (now Slaters) – Dingle garage on Abergele Road and Francis garage on Conway Road, West End (now the site of Lidl), all looked after the cars in Colwyn Bay. Meanwhile, Meredith and Kirkham garage on Abergele Road in Old Colwyn tended to service the vehicles on the outer reaches of the town. There were smaller outfits such as Mochdre garage on Conway Road, Wynn service station on Abergele Road, Old Colwyn, and Greenfield garage on Back Greenfield Road, Colwyn Bay. As many of these names suggest, it was a large service industry, employing several hundred men and a handful of ladies on secretarial

duties. In Braid Brothers garage on Abergele Road there was a mechanic, a small chap called Eddie German, who lived across the road in a house at the top of the cul-de-sac, Merion Gardens. During the war, he insisted that his colleagues should all call him Eddie Germain, preferably in a Welsh accent, but of course he remained Mr German and was ribbed incessantly for it all the way through the fifties. On the other hand, at W. C. T. Davies, a vehicle engineering firm next door to the library on Woodland Road West, worked Mr Laurie Bradshaw; he had fought in Italy as a soldier, been captured and spent a long time in a prisoner of war camp. He received natural respect for the rest of his life.

On 30 November 1952, the Old Colwyn railway station closed for ever. Old Colwyn, as its name suggests, was the original 'Colwyn' before the present Colwyn Bay existed and, with the closure of the station, Old Colwyn was more or less enveloped by the larger area of Colwyn Bay. This development was a natural consequence of the town's changing fortunes.

The tramway system ran from the Greenfield terminus in Colwyn Bay to the West Shore in Llandudno. It had originally extended all the way to the Queen's Hotel in Old Colwyn, but by 1950 the extra 2 miles had been lopped off. The last tram made its final trip on 24 March 1956, and one of the fleet broke down in Penrhyn Bay on that very day.

Coaches, or charabancs as they were popularly called, were all over the place, ferrying the locals around the district but, more essentially for the economy of Colwyn Bay, bringing in the holidaymakers from Manchester, Liverpool and the Midlands. The Crosville office on Conwy Road was the stopping and pick-up spot for this holiday trade. People were also, of necessity, riding bicycles, a habit picked up during the war years; this mode of transport was given a fillip when the Round Britain Cycle Tour passed through the town in 1953.

After the privations of the war years and the money expended on defending these islands, there was little money left to build new roads, but by the late 1950s the increase in traffic meant that something had to be done. It was, however, another thirty years before the A55 was constructed through the town.

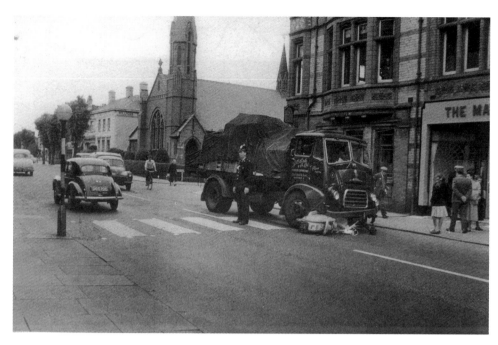

A sign of the times, but still a rare sight; a traffic accident in 1959 outside what is today Barclays Bank. The zebra crossing was new and the rider on the scooter was a learner driver who had lost control and, in a panic, swerved and ended up under the front of the lorry.

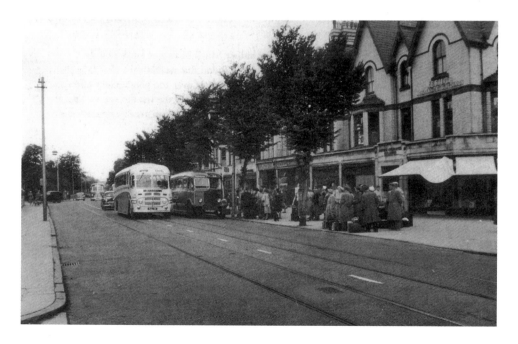

The Crosville coaches in 1954 outside the Crosville offices, on Conwy Road, which was the pick-up and dropping-off spot for the holidaymakers. It was a busy place every Saturday morning during the summer season.

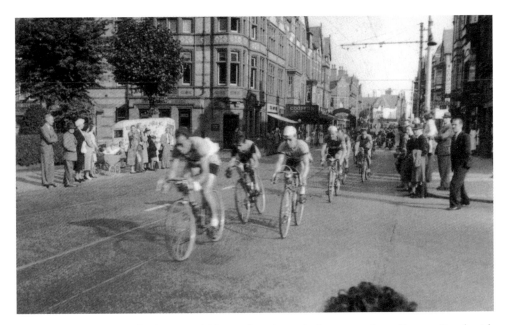

The Round Britain Cycle Tour in 1953, passing through the town along Conwy Road with Hawarden Road off to the left. On the right-hand side of the road were located the old 1950 businesses: Tapp-Smith, the hairdresser; E. A. Neill, the chemist; J. M. Porter & Co., the estate agent; and Frederick Clough, the solicitor.

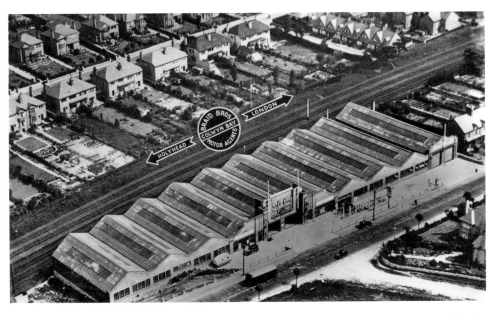

Braid's Garage had had a boost during the war, when the business was working at full-tilt, assembling army vehicles of all sorts. This success continued during the following decade, as can be seen in the picture. The business sustained further premises in Colwyn Bay, on the corner of Erw Wen Road and Abergele Road.

Chester Engineering Garage on Princes Drive in the 1950s was a thriving concern. The Arcadia Theatre and post office can be seen in the background.

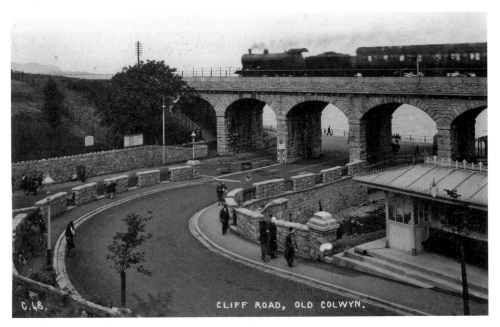

CLIFF ROAD, OLD COLWYN.

The train, in 1956, is on its way from Old Colwyn to Colwyn Bay station and passing over the bridge at the bottom of Wynnstay Road. The A55 dual carriageway also now straddles this gap. As a young boy, Bill Meredith, whose father owned Meredith and Kirkham garage, daringly inched his way across the parapet on the outside edge of this bridge, only to lose his nerve halfway across. Much to the annoyance of his mother, he had to be rescued by the emergency services.

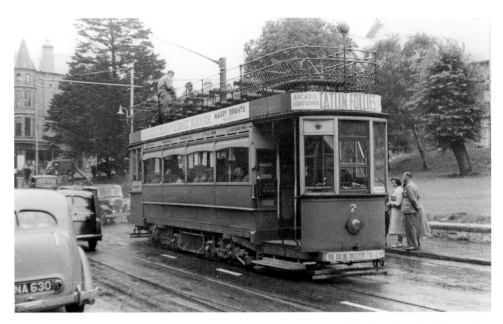

A typically chaotic traffic scene on Abergele Road outside St Paul's church in the fifties. The tram lines were a good way away from the pavement so that, when the tram came to a stop, there was always a jam of patient drivers behind.

Two of the most prominent coach firms were those owned by Sam Hancock in Old Colwyn, and Jim Pye in Colwyn Bay. This is a picture of Mr Pye's booking office behind the tree on Prince's Drive, next door to the post office, on the land now occupied by a car park.

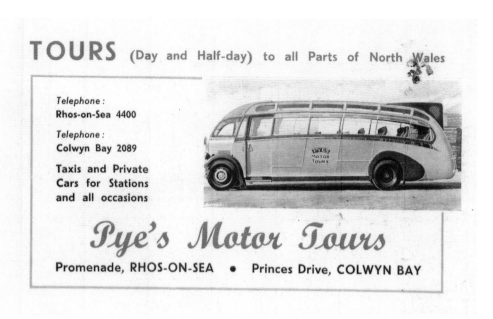

TOURS (Day and Half-day) to all Parts of North Wales

Telephone:
Rhos-on-Sea 4400

Telephone:
Colwyn Bay 2089

Taxis and Private Cars for Stations and all occasions

Pye's Motor Tours

Promenade, RHOS-ON-SEA • Princes Drive, COLWYN BAY

A Pye's advertisement from a Colwyn Bay brochure of the fifties.

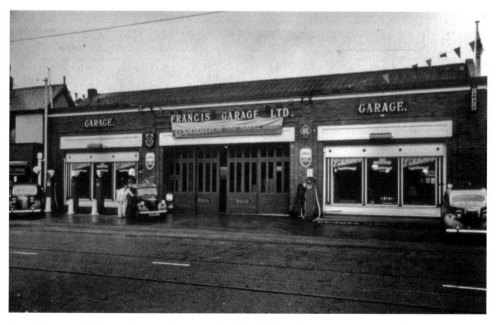

Francis garage, West End (now the site of Lidl), a bulwark of the motoring world in the fifties. Jim Francis, the son of the owner, loving horse-drawn vehicles rather than the mechanical ones, set up his own riding stables on Rhos Road.

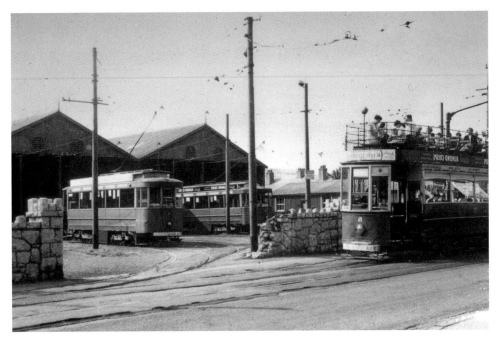

A tram arriving at the 'tram sheds' on Penrhyn Avenue, Rhos-on-Sea.

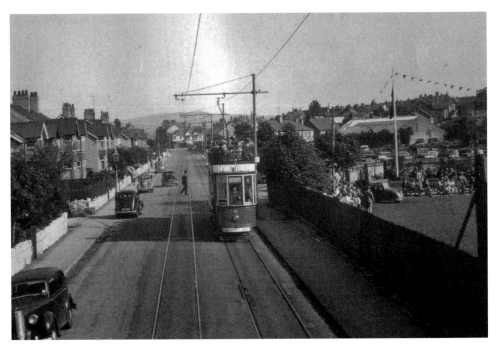

A double-decker tram passing the cricket ground, where there is a summer cricket festival in progress.

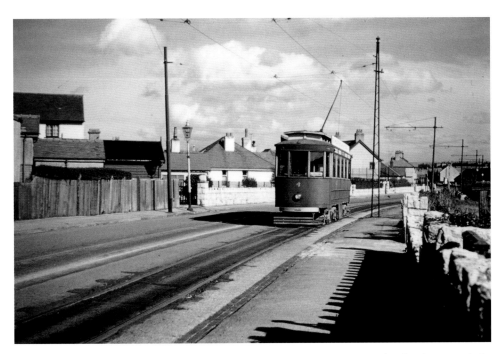

A single-decker at the end of Penrhyn Avenue, Rhos-on-Sea, in the final year of the trams' existence.

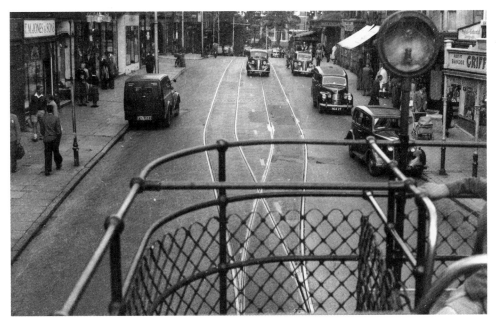

From the top of a double-decker tram, heading down the slope towards St Paul's church and Woolworths.

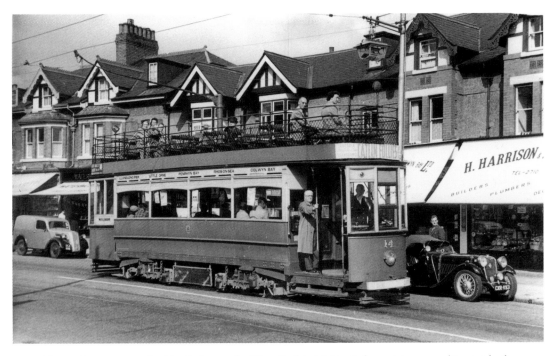

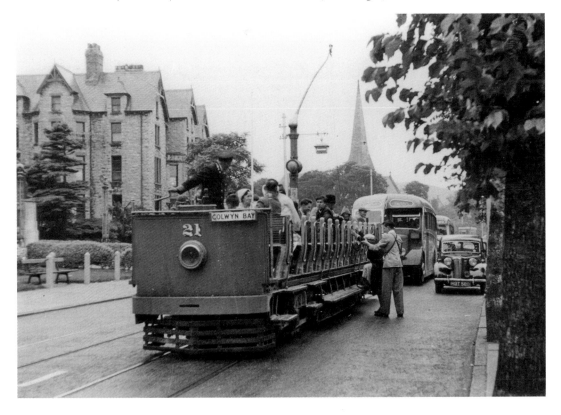

Above: An open-top double-decker at the West End in 1954. *Below:* A 'toast rack' outside the council offices (on the left) and Williams Deacons Bank (on the right).

4

THE CORONATION

I can still vividly recall sitting cross-legged on the floor in front of a small black-and-white television set as a ten-year-old boy in 1953, in a flat with the curtains drawn, in Penrhyn Court on Abbey Road, Rhos-on-Sea. It was the home of Mr and Mrs Donald Bird, parents of John, a friend of mine. I sat there for hours and was mesmerised, much to the amusement of the surrounding adults.

On 8 February 1953, Colwyn Bay's Proclamation of the Queen's Accession had been read in front of the council offices by the mayor, Cllr Gordon Kerry, in front of a large crowd, which included hundreds of excited schoolchildren. A few days later, Cllr Kerry led a civic memorial service for the late King George VI, at which the mace was carried with a black-mourning ribbon around its shaft.

For much of 2 June, the streets of Colwyn Bay were quiet, as most people were huddled around the few television sets to be found in the more affluent homes while, in what was seen at the time as an excitingly enterprising and forward-thinking move, some of the local schools had purchased televisions. For once, these schools attracted an eager and willing audience, even though it was a holiday. Six-hundred other children, along with their parents, watched the pageantry projected onto two screens in the Pier Pavilion. On the sloping embankment across the road from the Pier, a design of flowers could be seen, forming the words 'God Bless our Queen. Long May She Reign'.

On 31 May 1953, Roger Taylor left school, and on the following day he joined the staff of Martin's Bank in Colwyn Bay. He was immediately given the task of decorating the bank with Coronation bunting, and the next day, along with all the other staff, was given the day off work. On his one day's holiday, the day of the Coronation, Roger went to Corbiere, the home of Pat Allen, on Prince's Drive. Mr Allen, the owner of Daniel Allen's Department Store, was the owner of the day's most precious piece of furniture, a television.

The council decreed that street decorations were to be put up prior to Saturday 30 May and that they were to remain in position until Monday 8 June, and that there was to be a Coronation service in Eirias Park on the afternoon of Sunday 31 May. However, as most schoolchildren would not be available on Coronation Day itself, the proposal to stage a 'living flag' display had to be abandoned.

Miss Joan Bellis, a young teacher at Conwy Road Primary School, returned to school the day after the Coronation; one of the girls in her class remarked that she had thought

that the tall man in the long cloak, who turned out to be the Archbishop of Canterbury, was going to drop the crown as he put it on the Queen's head. She asked Miss Bellis whether, at that point, she also had been nervous. Miss Bellis replied that she hadn't seen it because she didn't have a television, whereupon the little girl said, 'Oh, what a pity, you could have come to our house to watch it.' The girl was on free dinners.

A competition had been arranged to discover the best decorated street in the town, and Park Road won. One housewife in the road had dyed her curtains red, white and blue. All the major shops in the town were festooned with bunting and portraits of the new monarch. The mayor, Alderman Leonard Firth, planted an oak-sapling in Eirias Park, one of many hundreds that must have been planted that year, and the first baby born on 2 June at the Maternity Home, known during the war as the Swell Hotel, was presented by him with a gold spoon, bearing the coat of arms of the borough. What turned out to be an invaluable tool for future historians of the town, the book *Colwyn Bay, its Origin and Growth* by Norman Tucker, was commissioned by the council to mark the royal occasion.

Jim Pye, who lived in Everard Road, Rhos-on-Sea, and owned Pye's Coaches, was the only person in the road to own a television. Everyone crowded into his living room, including a young boy from next door, John Evans, who many years later became the vicar of Colwyn Bay.

Just over a month later, on 19 July, as part of the Coronation celebrations, the Queen visited Colwyn Bay. Thousands of excited and curious townspeople lined the streets as the long line of official black Daimler cars drove sedately along Conwy and Abergele Roads. At the time I was at a boarding school in the Sychnant Pass, just outside Conwy, and we were marched down to the cob in the town, beside the suspension bridge; we lined up with pupils from around ten other local schools and we were all instructed that, as the Queen passed in her motorcade, we were to throw our caps high into the air and cheer. Half an hour after she had passed us by, much to the frustration of the teachers, we were all still trying to sort out the jumble of caps which were strewn all over the pavement.

Over the ensuing five decades, the Queen has remained the one constant star in our lives. Since her first visit to Colwyn Bay in 1953, making the present author and all young people of the fifties feel ancient, she has played host, when they stayed in London, to twelve Presidents of the United States: Harry Truman, Dwight D. Eisenhower, John F. Kennedy, Lyndon Johnson, Richard Nixon, Gerald Ford, Jimmy Carter, Ronald Reagan, George H. W. Bush, Bill Clinton, George W. Bush and Barack Obama.

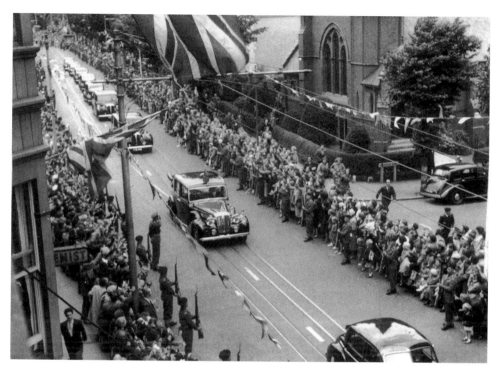

10 June 1953. The Queen and Prince Philip, Duke of Edinburgh, driving through Colwyn Bay past the English Baptist church at the top of Hawarden Road. The shops and offices had been closed for the duration of the motorcade, and the townspeople had gathered on the pavements three hours in advance. The procession is seen leaving the council offices, just down the road on the left, where the Queen had been introduced to the mayor and other civic guests. As can be seen from the photograph, the main road was lined with troops, from Mostyn Road to Greenfield Road.

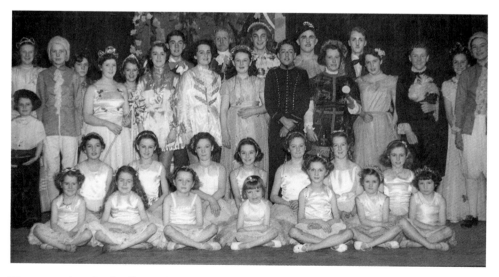

The pantomime *Cinderella*, produced by Mr and Mrs Gordon Kerry in 1953, at the Congregational Church Hall in celebration of the Coronation.

5

ENTERTAINMENT

The 1950s were years boxed in by the forties – years of austerity, sadness at the loss of so many good lives in the service of their country, loyalty, deference to authority, tiredness, self-sacrifice – and the sixties; Beatle mania, the contraceptive pill, mini-skirts, the drug scene, demonstrations against the first Vietnam War and the Rolling Stones. For some, the 1960s were a time of personal liberation. In the 1950s, those middle years, what was on offer in the cinemas, in the swimming pool and in the fun fair in Colwyn Bay was a staid, relaxing mixture of enjoyable fun. In 1953, Josephine Baker, the Jazz Age siren, created a 'family of the future', using multi-racial children adopted from all over the world. Colwyn Bay, however, was very much a white enclave of the entertainment world, and was a true representation of the mores of the day. No show was intended to harm or cause offence. By and large, they were happy years. The BBC echoed the sentiments of the years when, in January 1950, the children's programme *Listen With Mother* was first broadcast; later in the year *Educating Archie*, featuring Max Bygraves, was also broadcast for the first time. It was a time when to make arrangements with your friends to go to the pictures (as films where then known) was not easy; few homes had telephones, and many of those that did still had a 'party line' shared with another household. This state of affairs is highlighted by the fact that, in December 1954, the council considered a request for more telephone kiosks to be provided in Llysfaen.

In Colwyn Bay there were six cinemas doing a roaring trade. Seventy years later, they have all gone, while four of the buildings in which the films were shown are still standing. These picture palaces had been packed during the war, when they were used as an escape from the reality of war and its aftermath. Almost unnoticed, the 1950s were witness to a slow dwindling of the cinema audience. In January 1957 the Odeon, the town's largest cinema with 1,700 seats, which were full every night during the 1940s, closed for twelve years until it reopened as the Astra entertainment centre and struggled on for a few more years. In 1958, two more cinemas closed, the Supreme in Cefn Road, Old Colwyn, and the Cosy on Abergle Road, which closed in 1955. The Cosy was a tiny building, now (in 2014) hosting Matthews' Hardware Store, where the customers entered the building under the screen, thus allowing the small audience to monitor everyone who came in; the amorous members of the audience used the double seats in the three-row balcony.

Out of the shabbiness of the war years emerged a pleasant, unsophisticated, jolly musical decade. In February 1958, Winifred Atwell played honky-tonk piano aboard a BOAC Britannic Airliner between London and New York; a year earlier, the Tiller Girls kicked their long legs high in the air at the National Radio and Television Exhibition. In the same year that the Tiller Girls were bouncing along in unison, the twenty-year-old Shirley Bassey from Cardiff was singing in Las Vegas, while Alma Cogan, 'the girl with a giggle in her voice', was the highest-paid singer of the era. From across the Atlantic drifted the voice of Frank Sinatra, thrilling the young people of Colwyn Bay when he released his lovely themed long-playing records, all arranged by Nelson Riddle: 'Songs For Swingin' Lovers', 'In the Wee Small Hours', 'Only The Lonely' and 'A Swingin' Affair'. All these influences infiltrated the time spent by the people of Colwyn Bay, as they whiled away their leisure time in the Pier Pavilion or the Colwyn Theatre, on Abergele Road, listening to the band concerts on the Promenade bandstand during the summer season or enjoying the swirl and excitement of Pat Collins' amusement park on Victoria Avenue.

The Pavilion on the pier, which was the third such building on the pier (the first two having been burnt down in 1922 and 1933), was the main place to hear live music and popular concert shows. This was a legacy of the Second World War, when the pavilion had been a popular venue for entertainment; it was an enjoyable pastime which continued into the 1950s. On one day in August, during the Coronation year, 4,000 people passed through the pier turnstiles. Sadly, however, the traditional variety shows were playing to ever-falling audience numbers, and the summer seasons were becoming shorter and shorter. In 1958, they were discontinued altogether and were replaced by cheaper forms of entertainment, while the pier orchestra managed to struggle on as a threesome for a few more years. The fifties were witness to the end of the glory days for the pier.

Pat Collins had opened his amusement park in the Easter of 1935, on a piece of spare land between the railway goods yard and Victoria Avenue (both now demolished to make way for the A55 dual carriageway), and had surprisingly been able to keep it operating during the war. By the 1950s, the park had become an established part of the town's culture and allure. People travelled from far afield to spend time on the carousel, which was called 'Pat Collins' Famous Galloping Horses' and eat in the small café. Mr Collins owned an enormous dog called Tiger, which plodded around the grounds and became a treasured part of the scene, while the shooting range used old service rifles and live ammunition.

As well as the pier and the promenade, Eirias Park was considered the other centre for relaxation. There were two bowling greens, tennis courts, a 9-hole golf course, a boating lake for model boats and an artificial lake on which you could use a canoe for half an hour; there was an outside stage, where Mr Bramall first performed his marionette show, and a well-appointed café. The park had been opened on 7 September 1923 and, by the 1950s, the war-weary people of Colwyn Bay and of North West England invaded the area with relief and, although constrained by the mores of the day, with as much glee as they could muster.

Circuses visited the town each year during the fifties. They were a popular and exciting form of entertainment at a time when watching television was still a minority

form of relaxation, and before people became swamped in a tidal wave of every conceivable sort of entertainment. Bertram Mills' and Robert Fosset's circuses visited the town each year, when lions and tigers performing in a cage was thought to be fascinating and exciting. The idea that it could be cruel was never considered.

The entertainment world was on the cusp of parochial, amateurish, jolly local fare, championed in the demob post-war years, and that of the fast enveloping, experimental, professional and colourful theatre populated by the likes of Richard Burton, Keith Baxter, Peter O'Toole, Albert Finney and Alan Bates, who were all together at the Royal Academy of Dramatic Art in 1955. Some years later, the actress Barbara Jefford, who acted alongside John Gielgud and had appeared in the Pier Pavilion during the war, summed up the attitude of the times when she said, 'Nowadays, young actors don't hold their elders in awe as we did then.' As if to underline these sentiments, in the fifties, Colwyn Bay became home to the traditional, age-old form of entertainment, the marionette show. This was introduced into the summer shows in Eirias Park, and eventually into a purpose-built theatre in Rhos-on-Sea by the harlequin genius, Eric Bramall.

A picture of Pat Collins' fun fair, taken from the railway. The fair was on the spare land between the coal yard and Victoria Avenue, and it was one of the main centres of amusement for children and adults alike during the summer months. In the fifties, Alan Roberts used to take his son Graham to the fair each year, on the day before he returned to boarding school, a glaring and poignant example of the fair's importance in the lives of the local people.

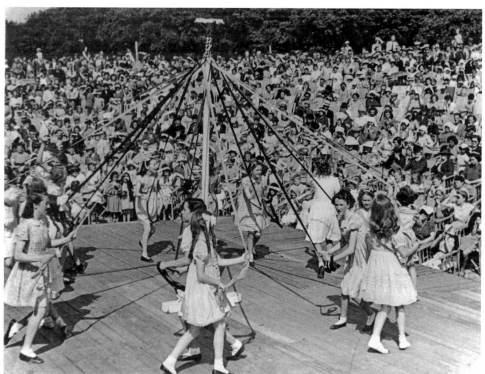

A hot May Day in Eirias Park in 1954. The crowd of onlookers are sat on the grass embankment. The men are wearing their regulation trilby hats and many of them are wearing ties. This was a delightfully innocent age when such an activity could draw an enthusiastic audience.

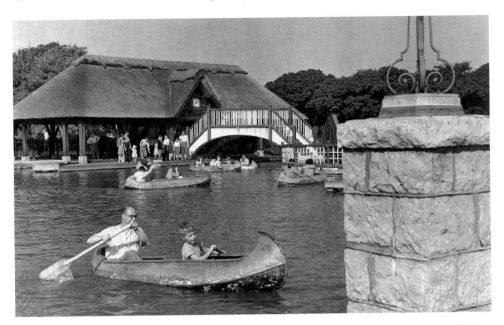

The canoe lake at Eirias Park. There were about thirty boats, all designed along the lines of those used by fir-trappers in the northern wastes of Canada. The waiting area, and that where the boats were kept, had a thatched roof. Everyone waited patiently in line for their turn and, when summoned by the attendant after their allotted time-span, the canoeists dutifully returned.

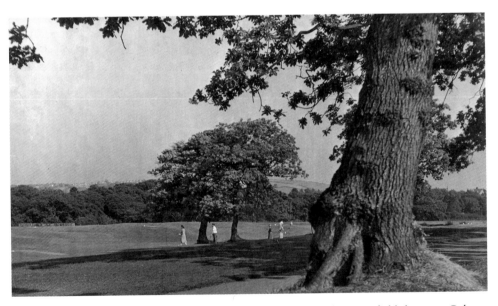

This looks like a rural country scene but is in fact Eirias Park, on the green fields between Colwyn Bay and Old Colwyn. It is the 9-hole holiday golf course used, in the main, by holidaymakers who did not normally play golf. The grammar school was just behind where the photographer stood. The council, as their contribution to the Festival of Britain in 1951, transformed the site of 350 former allotments in Eirias Park into a sports arena and running track, which was off to the right of the picture.

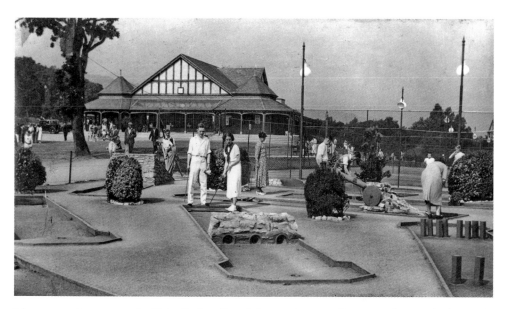

The par-putting course, the Eirias Park café and the tennis court. Sixty years later, only the tennis court remains.

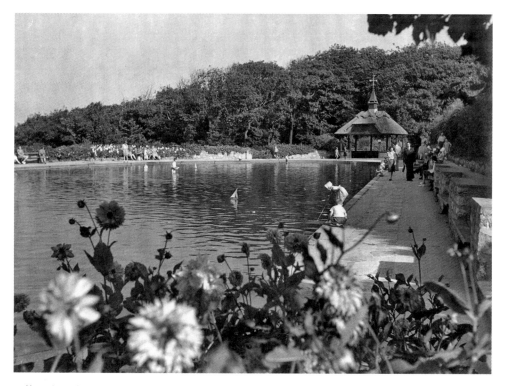

Off to the left, as you walked up the road to Eirias Park, was the lake used exclusively for sailing model boats. In the 1950s, the models were simple affairs but sailed with great enthusiasm; none of them were remote-controlled and many of them were built by their young owners.

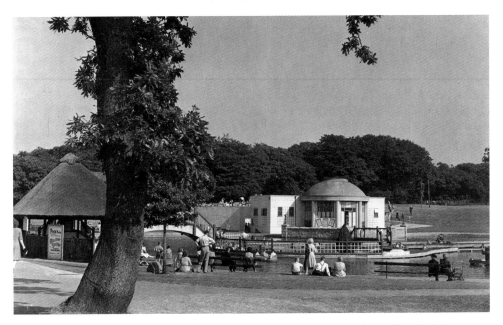

In the background can be seen the back of the open-air theatre. Over the wall to the left you can just see the upper tiers of the audience, who are sitting on the grass embankment. The sign to the left is advertising the 'Holiday Show' in the Pier Pavilion. Notice the man sat in the foreground with his braces showing, having obviously been persuaded to take of his jacket, and the lady sat on the bench to the right in her fancy hat.

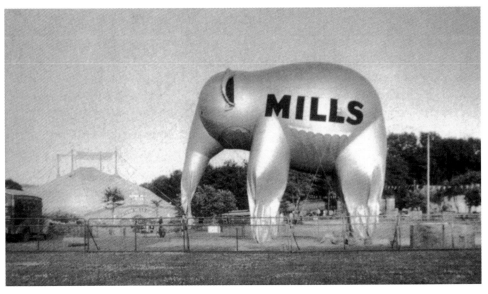

In 1955, Bertram Mills' circus came to town and erected this inflatable elephant as an advertisement in Eirias Park. The circus arrived on its own train, and paraded from the railway station through the town to the park. The train was left in the train sidings while the circus completed its week's performances.

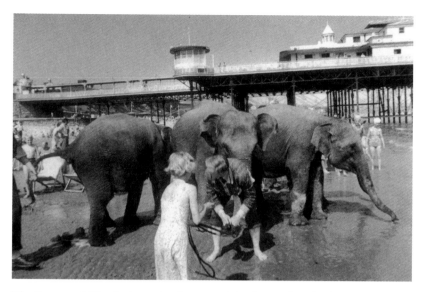

The Bertram Mills elephants having a wash in the sea beside the pier. This was really an advertising ploy to remind the holidaymakers that the circus was in town, and to encourage them to go and see the show.

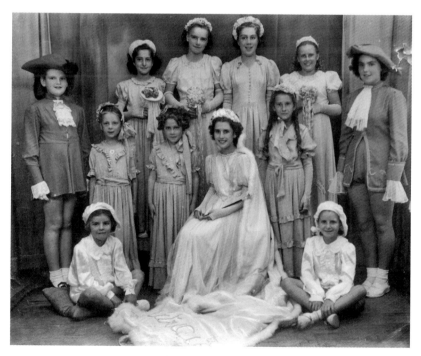

In 1950, Pat Newall was the Tan Lan (Old Colwyn) May Queen. The picture is a glaring indication of the changes that have taken place over the last sixty-four years. It is unlikely that young girls today could be persuaded to dress as Pat and her 'courtiers' did in 1950, only five years after the end of the Second World War. The fifties were happy years before ridicule had become fashionable.

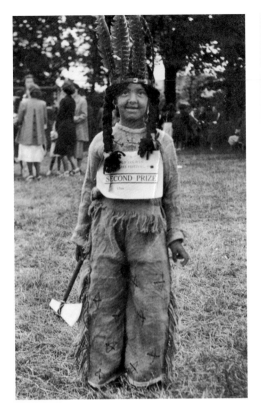 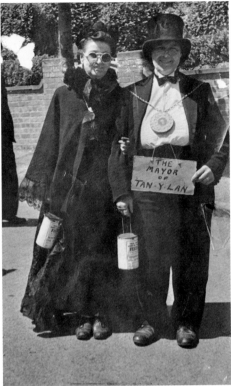

Above left: An Old Colwyn May Day entrant in the fancy dress parade. She won second prize, dressed as a Native American.

Above right: Lal Jones, on May Day, dressed in a mocking way as 'The Mayor of Tan Lan'. In reality there was no such office.

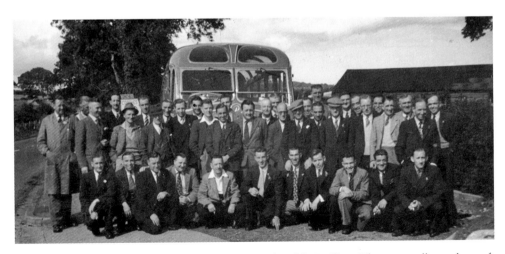

A fifties outing for the retired members of the Royal Welsh Fusiliers. They were all members of the British Legion Club and, as former soldiers, were well-respected members of the community and a tight-knit band of brothers.

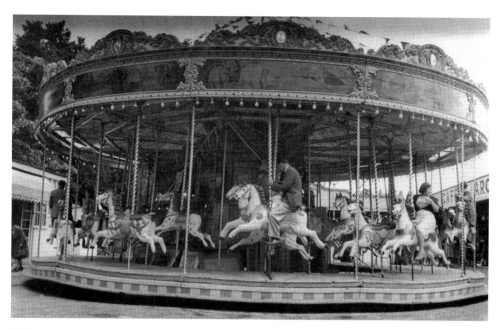

This was the lively scene at Pat Collin's amusement park in August 1950, showing his Gallopers in full flight. The café was on the left and Victoria Avenue was behind the person who had taken the photograph.

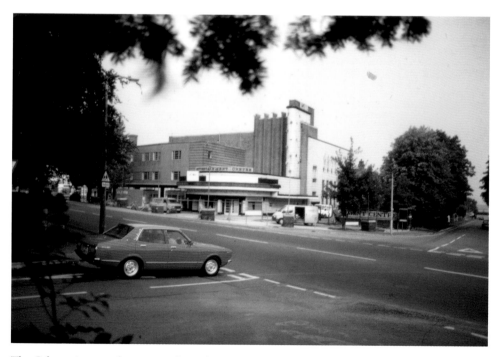

The Odeon cinema where, every Saturday morning, there was a special performance exclusively for children. There were seven rules, one of which now sounds very quaint, which announced: 'The Club is British, same as the Odeon, and we are all united under the one flag – The Union Jack.'

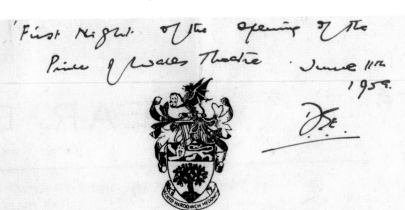

'First Night· of the opening of the Prince of Wales Theatre · June 11th 1959.

THE PRINCE OF WALES THEATRE

COLWYN BAY

Proprietors BOROUGH COUNCIL OF COLWYN BAY

Manager for the Borough Council (Tel. 2668) J. E. NEAL

By arrangement with the Borough Council

GEOFFREY HASTINGS

presents

"DEAR DELINQUENT"

By JACK POPPLEWELL

Thursday, June 11th to
Wednesday June 17th, 1959

PERFORMANCES ONCE NIGHTLY AT 7.45.

Doors open at 7.15 p.m.

PROGRAMME - - - - - SIXPENCE

BOX OFFICE OPEN FROM 10 a.m. to 12.30 p.m. and 2 p.m. to 4.30 p.m.

TELEPHONE — COLWYN BAY — 2668

First night of the opening of the Prince of Wales Theatre (now, in 2014, Theatre Colwyn).

In many a long day's march . . .

You'll never find another!

There is only ONE—

HARLEQUIN Puppet Theatre

Cayley Promenade - Rhos-on-Sea

●

★ The first and only puppet theatre to be built in Britain

★ Afternoon performances at 3 for children

★ Evening performances at 7.45 for adults

●

Presenting—*THE*

ERIC BRAMALL MARIONETTES

YOU WILL NEVER FORGET YOUR VISIT TO THE HARLEQUIN

An advertisement for one of the most popular forms of entertainment in the 1950s in Colwyn Bay.

6

SPORT

Throughout the war years, sport had played a major part in the life of the town. While other towns had suffered from the disruption of the war, Colwyn Bay had gained from an increase in the number of civil servants working in the town and from the lack of bombing. Sport had been a means of relaxation and social interaction. While the fifties saw the departure of the majority of the Ministry of Food civil servants, the idea and habit of sport continued to be enjoyed at a time when television was still in its infancy.

In 1951, at the Min-y-Don Bowling Club in Old Colwyn, when Mr W. Turner was president, an open tournament was played which raised £22 12s for the Cancer Research Fund. In the same year a 'very substantial meal' was provided by the president at the Plough Hotel to celebrate the promotion of the team to 'Section A', and it was decided that the members should go on an outing to Beddgelert, when a thirty-three-seater charabanc was hired from Sam Hancock for £9. Tea was provided for 4s 6d per head.

There were eight bowling greens in the Colwyn Bay area: one in Llysfaen, one in Old Colwyn, four in Colwyn Bay (two at Eirias Park, one at the Conservative Club and one at the British Legion Club), two in Rhos-on-Sea (Allanson Road and Penrhyn Avenue) and one in Mochdre. There was very little money about, and young people had little opportunity to meet each other except on the playing fields of the town and in the cinemas. Visiting pubs, in Colwyn Bay at least, was for older people. Parents encouraged their children to play.

Colwyn Bay Cricket Club had prospered during the war, and it continued to enjoy much success during the following decade. During the war the club raised a lot of money for worthy causes but, in the 1950s, the main concern of the club committee was to find enough money to build a new clubhouse; they were successful, and the new pavilion was opened by the Duke of Gloucester in June 1960. The fifties were also witness to many benefit matches for such famous cricketers as the England and Lancashire batsman, Cyril Washbrook, Learie Constantine from the West Indies, Len Hutton, the captain of the English team and Yorkshire player – whose match in 1950 realised £200 – and the England wicketkeeper from Kent, Godfrey Evans. It was in the fifties that the club initiated their nationally famous Cricket Festivals, which lasted a week and featured a two day match between a County side and a touring team. One of the favourites was the West

Indies, having such players as 'the three Ws': Worrall, Weekes and Walcott, with spinners Ramadin and Valentine in support.

In the early fifties, a number of enthusiasts got together and began to organise cricket games on the old Colwyn Bay Football Club field at Mochdre. Only players living between Dolwyd and Brompton Avenue could join the team, thus restricting members to the actual residents of the village. The teams were made up from the various streets in the village and each street team had a designated colour, so that, for instance, the Bryn Marl Road team was the red team and the council estate team was the green team. In the beginning, they only played in the evening and, later in the fifties, fixtures were arranged against Braids garage, Crosville Buses and Coldrator (later known as Hotpoint) Refrigerators. At the start of the decade, there were no changing facilities until, in 1953, the players found an old Victorian bathing hut that had been used fifty years earlier on the Colwyn Bay beach, into which about twelve players could squeeze. In 1954, when J. K. Smits' new building was built, the pitch had to be moved to the field behind the abattoir, across the river from the town tip. On one occasion, in a dry summer, the pitch was watered via hosepipes provided by the local fire brigade and using water from the abattoir. What with the tip and the abattoir water, the whole area stank to high heaven. Ironically, in later years, once the tip had been flattened and seeded, it became the official Mochre Cricket Club ground.

There was a flourishing Welsh League football team, which careered around the sloping field in Eirias Park. Most of the team were semi-professionals, and most of them worked for the Diamond Tool Company on Princes Drive in Colwyn Bay. The owner of the company was also the president of the football team. The team had a very good wing-half, Bill Lawton, who also played cricket for the Lancashire League and wore contact lenses, an aid of great wonder in the 1950s. Bill Lawton's other claim to fame was that he was the husband of the actress Dora Bryan. They were childhood sweethearts and married in 1954, after having been engaged for thirteen years. People in Colwyn Bay were amused to learn that Miss Bryan was annoyed when she read the newspaper headline: 'Cricket Hero Bill Lawton Weds Actress'.

Athletics, badminton, football, rugby and other sports flourished in the 1950s. With the help of a group of Rydal schoolmasters, the dedication of Tom Bellis and the enthusiasm of Denbighshire's chief constable, Mr A. M. Rees, the rugby club was reformed. The new council owned sports arena in Eirias Park, which was created on the site of 350 allotments that Lord Woolton, the wartime Minister of Food Production, had persuaded the people of Colwyn Bay to tend, was built in 1951; it was first used for an athletic event when it was formally opened by the Lord Lt, Col. J. C. Wynne Finch, in July 1955.

In the relaxed and exhausted 1950s, horse riding was a popular form of exercise for all ages of people. The washing for the two local laundries, the Colwyn Bay Laundry and the North Wales Laundry on Rhos Road, was still collected and delivered by a horse-drawn wagon. There were one or two stable yards in the town, where horses were kept and hired out. Lines of horses bearing children could often be seen winding their way along the mostly empty roads. Pre-eminent among these stables was J. Fred Francis' at the top of Rhos Road, on the fields now occupied by the Brompton Park housing estate.

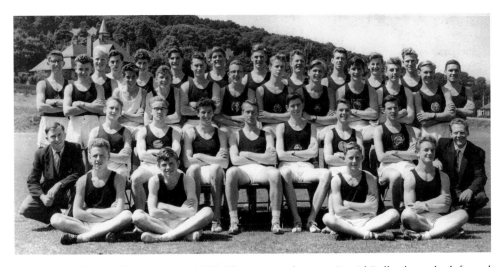

The Rydal School Athletic Team in 1959. The two teachers are David Pollard, on the left, and Ken Cooper on the right. Nick Pochin (of the Pochin Building firm) is the captain, sat in the middle, and the author is standing in the second row from the back, second from the right.

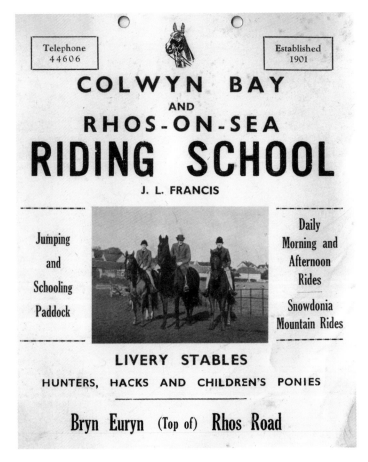

Mr Francis' advertising campaign in 1956.

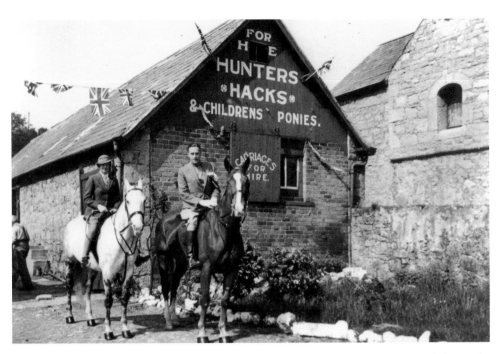

Some of Mr Francis' older riders on their way out of the stables. It is Coronation week, hence the Union Jacks flying from the barn.

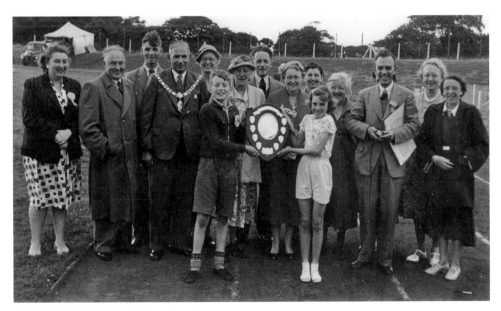

The Conwy Road Primary School Sports Day in Eirias Park, July 1955. The lady on the right is Miss Roberts, who taught the youngest children, and the man third from the left is Mr Jones, who played hockey for Wales. The lady fourth from the right is Miss Allen; she sported a face full of whiskers, which we children thought was hilarious.

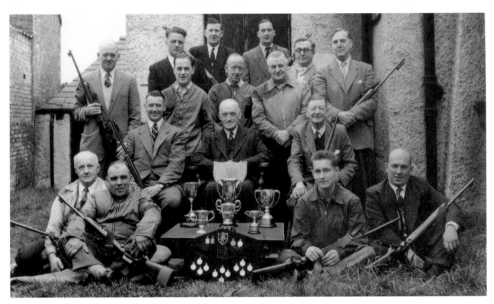

The 1955 Colwyn Bay Rifle Club, way before licences, health and safety and risk assessments, posing behind the Army Nissen huts on Prince's Drive. The man sat at the front, second from the left, was the *North Wales Newspaper* reporter, Trevor Williams, who wrote under the pseudonym of Cormorant; the man stood on the far right is George Lee, who was the proprietor of the Rhos Playhouse cinema.

Rhos-on-Sea Congregational Badminton Club in 1950. *From left to right:* Edith Whitehead; Margaret Bowers; Amy Fairclough; Edith Domney; Harry Hirst (who donated the cup and a 15s (75p) book voucher to all the members, which they are holding); Peter Cain; Olive Roberts; Syd Walburn; John Domney. With his book voucher, Peter Cain bought *Eastern Approaches* by Fitzroy Maclean, a book he still owns sixty-four years later.

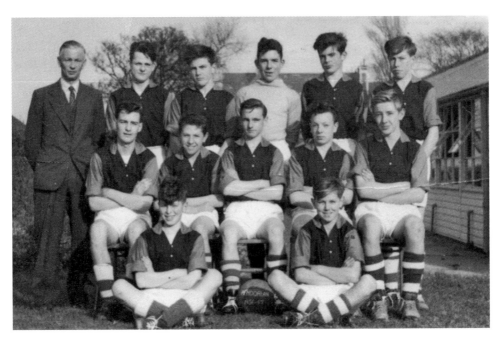

Colwyn Bay Grammar School Football Team (1956/57) with their teacher, Elwyn Roberts.

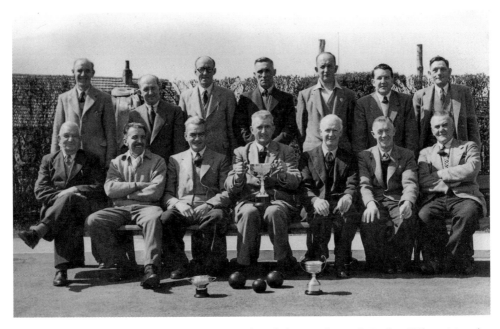

The Rhos Park Bowling Club in 1950. *Standing left to right*: Jack Butler, Wilson Murphy, Cliff Harris, Vic Griffiths, Harry Lloyd, Ces Owens, Arnold Broadhead. *Sitting left to right*: W. S. Owens (father of Ces), Bob Gledhill, Joe Roberts, Jim Barker, Hedley Wooller (President), Billy Hilton, Joe Taylor.

7

New Build

New people were arriving in Colwyn Bay in the 1950s from the bombed and devastated towns of England, especially Manchester and Liverpool. Many of these people were retired and had some money to invest in new homes. They had been educated in a more rigorous age and they knew what they wanted. It just so happened that in Colwyn Bay they discovered architects, builders and councillors, not yet overburdened with the heavy hand of planning regulations and bureaucracy, who could help them. This was still a time when the government felt compelled to tell people how to live their lives: 'Get Rid of that Bottleneck,' said the Ministry of Transport and Civil Aviation poster in 1957, 'By Staggering Working Hours.' In 1955, another poster declared, 'Staggered Holidays Help Everybody' and went on to explain, 'There's more room, remember, in June and September'. These posters, pasted up on huge billboards on the end walls of shops and garages, documented a vanished age, when we were told what to do and sometimes still even did what we were told. But the Colwyn Bay architects were having none of it. They wanted to think anew and shake off the shackles of a war-time strait-jacket that had been thrown around building innovation. The members of the council were also beginning to think artistically, and to understand that voters were beginning to think again about how things looked. In December 1954, the council members agreed to the removal from the council chamber of the paintings of Lord Colwyn and Miss Hovey and for them to be displayed in the Mayor's Parlour, for the painting of the Revd Thomas Parry to be hung in the Public library (where it still hangs at the top of the stairs on the first floor), for the painting of George Bevan to be moved to the borough treasurer's office and for the painting depicting a view of Colwyn Bay to be shown on the wall of the information bureau.

Boxed in between Elwy Road, Llandudno Road, Church Road and Rhos Road in Rhos-on-Sea were 18½ acres of open land and the council agreed that it should be used for new council houses. The architects, Sydney and his son, Ralph Colwyn Foulkes, designed 144 three-bedroom houses, four four-bedroom houses, thirty one-bedroom flats, and sixty two-bedroom flats along terraces with lanes for service access behind the houses, which were built and completed in 1956. The fifties, however, were years hobbled by restrictions and rationing in the construction industry. The Ministry

of Housing dictated the size of houses, and therefore the size of the rooms within those houses, and the amount of wood, bricks that could be used on each project. This accounts for the space used for each room within the Bryn Eglwys housing estate. Frank Lloyd Wright, the world famous American architect, was amazed at the restrictions imposed by the government on the building industry when he was shown round the estate by Mr Colwyn Foulkes and his son.

In 1954, the council expanded the Tan-y-Lan estate by building the houses on Sefton Road and Queensway, on the Uwch-y-Don Farm fields. This was not met with universal local approval, as the people living in this area had come to appreciate the primroses and cowslips that covered these fields in springtime and which were a blaze of colour in summer from the abundance of wild flowers, scarlet poppies, scabies and marguerites.

In 1900, Mochdre was a hamlet with five farms and a few scattered houses, but steadily, through two world wars and partly due to the Urban District Council buying Eagles Farm and all its land, the village grew. In 1951, alongside Glan-y-Wern Road, the borough council built the town's first post-war housing estate, which consisted of 200 houses, and in a trice doubled the population of the village. This trend culminated in April 1956 with the opening of the Mochdre village hall, designed by Stuart Powell Bowen, and costing £8,000. By the end of the 1950s, the town's virtual dependence on the holiday trade was over and, due to the new factories being built in the area, the number of men without work had dropped; new buildings were appearing and the town was beginning to take on a fresh appearance. This new optimism was helped along in 1957 by the building of an industrial estate at Mochdre.

A more sombre affair, but nevertheless a lucrative source of future income for the local authority, was the laying of the foundation stone on 16 August 1955 for the Colwyn Bay Crematorium. In September 1953, the council applied to the Ministry of Housing and Local Government for the sanction to borrow £25,850 for the construction of this building. It was designed in a pastiche of the Arts and Crafts style by Leonard Moseley, and was duly opened by the Right Honourable Earl of Verulam on Thursday 31 January, 1957.

A sort of old-build-new-build was the Tan-y-Lan community centre, which was opened in April 1951. It was 'old build' because it was an old First World War army hut discovered on the Great Orme, and 'new build' because it was reassembled on a new brick-built base, with the addition of a toilet block and kitchen, at the top of Sefton Road, below the cliffs of Penmaenhead.

In April 1950, and then in April 1952, William Hargrave Storrs and Ethel Hovey JP respectively laid the foundations stones of the Eventide Homes, now known as Heaton Place, in Rhos-on-Sea. Designed by Sydney Colwyn Foulkes, they were specifically for the use of retired people who had served the local community in some social and well-meaning fashion. The land, on which she kept ponies, was donated by Miss Heaton, surrounded by houses on Digby Road, Brompton Avenue and Ebberston Road West and remained useless until Mr Colwyn Foulkes persuaded the owners of the homes on Ebberston Road West to allow drainage pipes to be laid across their land and so drain Miss Heaton's field.

Otto Edward Gorst and his son, Donald, were building good quality homes in Rhos-on-Sea in the fifties. They had begun by building council houses in Llanddulas for Abergele Council, who were very slow in paying for the work, due to the austerity of those years. The houses on Stuart Drive (named after Edward's youngest son) in Rhos-on-Sea were built in 1954, and those on Marston Road in 1959, which were swiftly followed by all those along Cambrian Drive below Dinerth Road. Mr Gorst and Donald bought the 28 acres of land between Dinerth Road and the Afon Ganol River for £28,000, and created a superb estate of private housing.

In the summer of 1955, six foundation stones were laid by Donald Hughes, A. J. Costain, the Marquess of Anglesey, G. H. Taylor, J. A. Knowles and J. B. Clark for one of Colwyn Bay's pre-eminent buildings, the Rydal School memorial hall. It was designed by Sydney Colwyn Foulkes and includes a magnificent coffered ceiling. It was opened in 1957 and is a fitting and magnificent memorial to the forty-three former pupils of the school, who sacrificed their lives during the Second World War for our well-being.

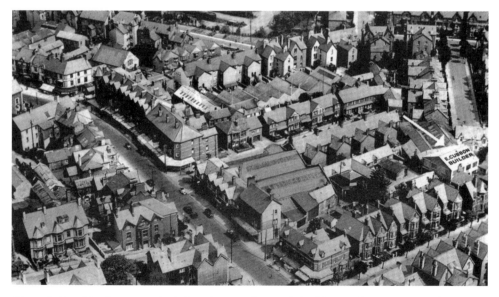

Abergele Road is shown on the left and E. Cubbon Ltd, builders and contractors, of Erw Wen Road in shown on the right-hand side of the picture. The firm had done much work for the Ministry of Food during the war and by 1955 were contractors to HM Office of Works.

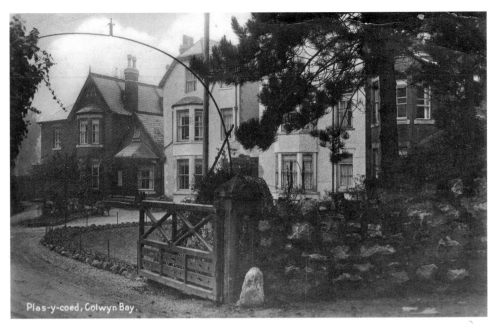

Plas-y-Coed, which had been used by the Ministry of Food during the war as accommodation for female civil servants, had, by the 1950s, been taken over the Methodist Church as a holiday home.

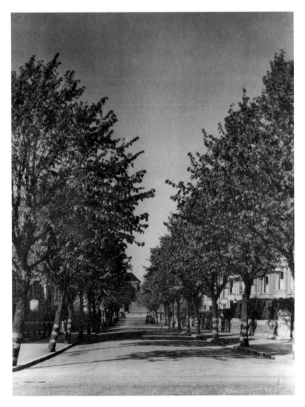

Wynnstay Road, Colwyn Bay, in the 1950s. The end of the post office building on Princes Drive can just be seen at the bottom of the road. In the fifties it was mostly residential, with Ken Leach's dairy to the left and the Royal Liver Insurance building also on the left. Only a few of the trees remain, and most of the buildings are now occupied as business premises: solicitors, accountants, architects, insurance and finance companies and local authority enterprise offices.

The Bryn Eglwys housing estate, showing Church Road at the bottom of the picture and Rhos Road at the top, with Elwy Road running diagonally on the left. The estate was built in the fifties to a design from Sydney Colwyn Foulkes. Above many of the front doors are castings of characters from the Edward Lear's poem 'The Owl and the Pussycat', and Lewis Carol's *Alice in Wonderland*. Frank Lloyd Wright, the world-renowned American architect, visited the estate during its construction.

Hilldermill, on a piece of land on the corner of Whitehall Road and the Cayley Promenade, which had been the garden of Mount Stewart Hotel, was designed in 1957 by Brian Lingard for Mr Pocklington, a master miller from Staffordshire, and is an example of new money moving into the area.

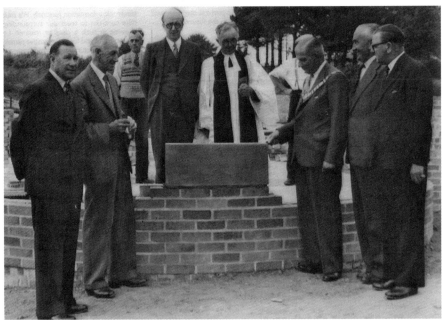

Laying the foundation stone for Colwyn Bay Crematorium on 16 August 1955. *Left to right:* Walter Ashworth (the builder); Leonard Moseley (the architect); John Richard Watson (in the background: clerk of works for the council); unknown; the vicar of Llangwstenin, the Revd J. L. Jones; the Mayor Cllr Edward Jones JP; Harold Braithwaite (the town clerk); Harry Blythe (the council gas engineer).

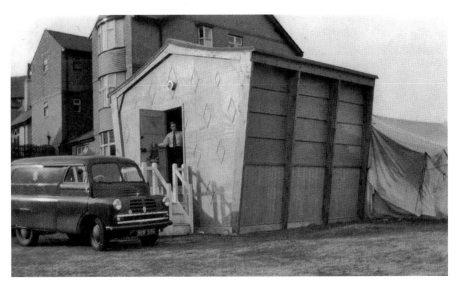

In 1959, Clough Williams Ellis, the creator of Portmeirion, presented the Civic Trust Award to Gwyilym Parry Davies for his design for the Puppet Theatre, the first of its kind, in the grounds of Aberhod in Rhos-on-Sea. The theatre, under its owner and inspiration Eric Bramhall, was opened on 7 July 1958 and is still going strong under the direction of Mr Bramhall's associate and friend, Chris Somerville. This is a picture of the theatre's temporary accommodation, in what Mr Bramhall described as a shed, which was on the small parkland opposite Rhos Point.

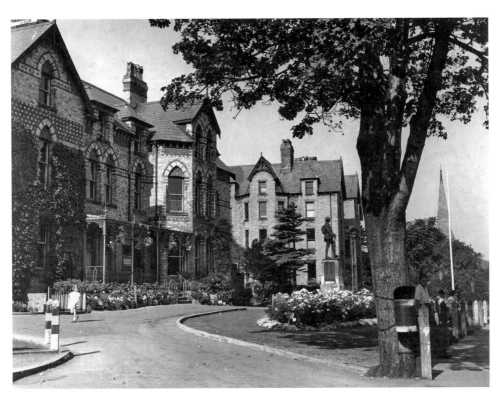

The town hall, the centre of the civic world of Colwyn Bay in the 1950s, on Conwy Road. Oaklands is in the background. In 1950, there were no female members of the borough council, but in the following ten years four ladies joined this men's club. The town hall has now gone and has been replaced by shops, the DSS and the Inland Revenue. The War Memorial has now been moved into Queen's Gardens, 100 yards down the road. All civic parades used to start from here, and it was here that the Queen stopped and spoke to the mayor, Alderman Leonard Firth, on her coronation tour of Great Britain.

The Gorst-built houses, designed by Stuart Powell Bowen, forming an arc around the base of Bryn Euryn.

Edward Gorst's houses, built in 1958, along Stuart Drive in Rhos-on-Sea.

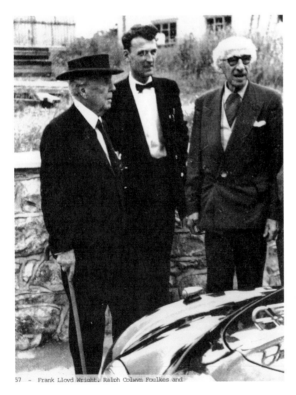

57 - Frank Lloyd Wright, Ralph Colwyn Foulkes and

In, 1957, Ralph Colwyn Foulkes (*centre*) showing Frank Lloyd Wright (*left*) and Clough Williams Ellis (*right*) around the partially completed Elwy Road Estate.

8

EDUCATION

In the 1950s, Colwyn Bay became an educational centre of excellence. There was a fine grammar school, a very good secondary modern school, two first-rate public schools, a highly thought of technical institute at Barberry Hill, a thriving Welsh school, a full Roman Catholic school and a batch of really good primary schools, in which children were taught the basic mathematics and English that stood them in good stead for the future. However, this was still a decade in which around a quarter of students qualified for a university place, but only 4 per cent actually went. It was also a time before the destruction of the United Kingdom into self-governing regions; the system used in this town's schools in the 1950s, and the money spent on them, all came from Whitehall. It was all straightforward and understood by the educational establishment. The idea of a comprehensive, national, universally accepted educational family was to decay over the following seventy years, when the legal supremacy of the British House of Commons was harmed in the 1970s by our joining the European Economic Community. The Colwyn Bay schools of the 1950s truly represented, to re-coin the poet Marvell's phrase, 'the great work of time'.

On St David's Day in 1950, a new Welsh school was opened in a former private house on Riviere's Avenue with a total of 300 pupils. The school took its name from the house, Bod Alaw, and the road was named after Jules Riviere, who had been the musical director at the Pavilion on Colwyn Bay Pier.

It was still a blackboard and chalk, an exercise book and pen, a desk and logarithms world. At the Electronic Computer Exhibition in London in 1958, the 'Multi-Purpose Electronic Analogue Computer', which was the size of a massive wardrobe, was on display. At the same time, in St Mary's Catholic School on Abbey Road in Rhos-on-Sea, the pupils, all boys, sat in serried rows at individual desks and paid strict attention to the teacher priest. It was also a paternalistic decade when Roy Tebbitts and his friends, pupils at Pendorlan Secondary School, would happily go off to what they referred to as 'Gwilym's Academy', where Mr Gwilym Griffiths was the excellent headmaster.

Miss Eluned Roberts and a group of pupils of Ysgol Bod Alaw during the 1950s.

Gwilym's Academy, the secondary modern school on Pendorlan Avenue.

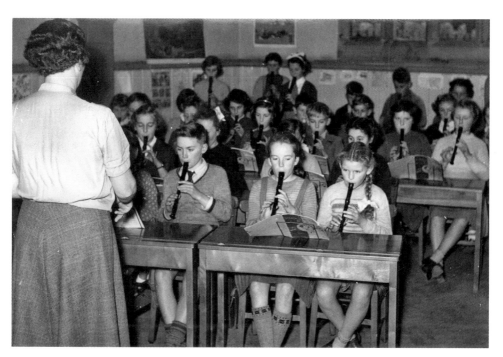

Miss Margaret Jones' recorder class at Conwy Road School in 1955, where Mr Griffiths was the forthright headmaster. It was a good school, where the pupils received a solid grounding in the 'Three Rs'.

Mrs John Jones presenting a cheque to Mr Griffiths, the headmaster of Conwy Road Primary School, on his retirement in July 1954.

9

NEW BUSINESS

The biggest problem for Colwyn Bay in the 1950s was adapting from what had been its principal business before the war, catering for visitors, to a new world in which foreign travel had become easier. New ways had to be found for local people to earn a living. One of the ways was to attract light industry to the town, and the council opened up land around Mochdre for this purpose. In 1955, the first factory was built, employing 100 women, and a start was made in diversifying the sources from which the working population of Colwyn Bay earned its living. By 1958, ten local industries were employing over 450 people, but the 1950s were years in which workers were still only vaguely aware of the need to have more control over their working lives.

J. K. Smit & Son, a diamond tools business which had operated above Bevan's the ironmonger's shop on Princes Drive, expanded and relocated to Mochdre, where they employed 100 people. This business had come to Colwyn Bay in 1940, when Mr Jan Smit had been able to spirit away from Holland, under cover of darkness and under the noses of the Germans, a valuable stock of industrial diamonds. In 1951, Mr John Prior started making plastic products in a small house in Colwyn Crescent in Rhos-on-Sea, but soon had to move to a new factory in Mochdre. Eric Quinton Hazell, who had started in 1948 with four men making spare parts for motor cars was, by 1958, employing fifty-five men at his large factory in the same village and, by the end of the decade, was employing over 2,000 people and selling vehicle parts in almost every country in the world. In a specialised way, Mr George Mellor started his model railway business in a small former horse stables, in an alleyway that runs from Rhos Road into Everard Road. He went from strength to strength, exporting his meticulously handmade, fully functioning models, all over the world.

Mr A. P. Bibby, who had started a garment factory in a former temporary church at the bottom of Coed Pella Road, had to move to Mochdre due to his expanding order book and the demolition of the church, while the Ratcliffe Tool Company in Coed Coch Road, Old Colwyn, went from strength to strength, as did Industrial Engravings, which took over the empty Supreme cinema in Cefn Road.

In 1955, Ernest Coathup made his son, David, aged fifteen, leave school and join him in his new business manufacturing diamond needles. They set up their production

in a tiny building in Pen-y-Bryn, Old Colwyn, back to back with the building used by Hugh Jones & Son, the undertakers.

The fifties were still years in which all businessmen were struggling to cope, and innovation and 'make do' were often the mantras of the day. One afternoon in the late 1950s, a covered wagon owned by a wholesale grocers, Christmas & Lovell, chugged up the steep Rhiw Road, and when it arrived at the junction with the Old Highway all the boxes came flying of the back, with the covering of tarpaulin flapping in the wind. All the boxes, fruit and puddings, which spewed out of the ruptured containers, were strewn over Seafield Road, Rhiw Grange and Rhiw Road. To Terry Deakin and the other local boys who were stood around watching, it was like magic. They all ate well that evening.

This was Victoria Avenue in the fifties, a road that ran from Greenfield Road along to the railway station and Prince's Drive. Pat Collins' fairground was on the left, and there was a tunnel running under the railway line on the right, which led down to the pier and promenade. There were no shops open and no trading on a Sunday, and this scene is typical of a Colwyn Bay Sunday morning in the decade running up to the swinging sixties.

Garstang's Ltd on Colwyn Avenue in Rhos-on-Sea was the largest wholesale greengrocers in the area, delivering produce all over North Wales and Cheshire. Their warehouse was constructed in the early 1950s, and was the largest of its kind in the North West.

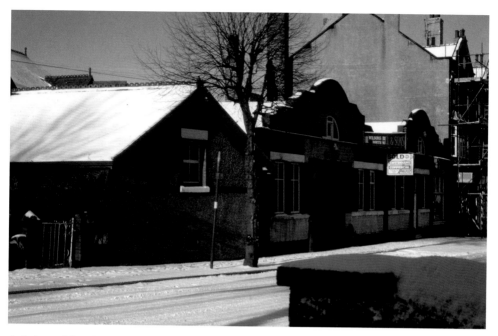

A thriving fifties business was the Everard Road Wine Stores of H. Westwell & Sons, where beer was brewed, much to the delight of the young boys, who used to stand at the big barn doors and smell the sweet aroma of hops.

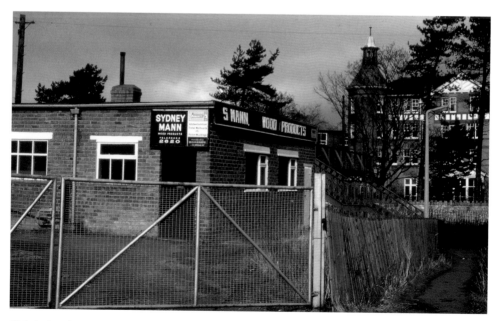

This is Stanley Mann's one-man-band business, Wood Products. The building was tucked away off Prince's Drive, down the cutting that led to the iron footbridge and Daniel Allen's Depository, and on across the railway line to Penrhos College for Girls. Before home self-assembly furniture was available, Mr Mann made kitchen furniture, timber wall boards and picture frames.

10

THE CHURCHES

The Coronation underlined the Christian nature of Great Britain. The Coronation service and the coronation oath are shot through with Christian beliefs and values, without which they would make no sense. In June 1953, the Queen promised to 'maintain the Laws of God and the true profession of the Gospel'. To the church-going folk of Colwyn Bay, both Welsh and English speakers alike, this was all very natural.

However, as an indication of the changing times which the 1950s represented, for four months in 1950 an exchange of pulpits was arranged in the English Baptist church in Colwyn Bay with the church in Aberdeen, South Dakota, USA. The Revd Arthur L. Slaikou came to the church on the corner of Hawarden Road and Conwy Road, and the Revd I. Vaughan Morris went to South Dakota. Revd Slaikou proved a hit; his Sunday services were so well attended that some people had to be seated in the schoolroom, and queues formed outside the church in order to get a seat. The following year, proving the Christian influence on the lives of the people of those years, the Revd and Mrs Vaughan Morris celebrated their silver wedding anniversary in the church, the same church in which they had started their married life.

Archdeacon W. Hugh Rees was the vicar of St Paul's church for the whole of the decade, an influential and popular figure in the town. St Paul's was considered, among the English speaking fraternity, as the pre-eminent place of worship. It had a social cache attached to it, which was much appreciated by certain dignitaries and civic leaders in the town. Tucked away on the North Wales coast, away from the likes of the murderous Kray twins who were causing mayhem in the London underworld, the people of Colwyn Bay prayed together in full churches in the 1950s, untouched by unsettling thoughts and violent acts of unkindness. Colwyn Bay was a peaceful town.

In June 1957, the Rhos-on-Sea congregational church held its Golden Jubilee celebrations presided over by the Revd Francis Dorken in 1955; he had taken over from Revd J. M. Holden, who had been praised on his retirement as 'an artist in letter-writing', an art which, sixty years later, is little practiced. An indispensable addition to the social life of the young people of Rhos-on-Sea was the setting-up, in the early 1950s, of the Rhos Congregational Boys Club by Mr Harold Knapper and his wife, Phyllis, who ran the club for the following forty years. A man purporting to be the brother of David Nixon, the popular magician of the time, visited the club and, much to the bemusement of the boys, performed some second-rate tricks. It was also a significant mark of the times, and readily accepted and unremarked upon, that the club was formed exclusively for boys.

Photograph taken in the grounds of the Old Colwyn English Methodist church, Wynne Avenue, in 1951, on the occasion of Miss Amy Chettle's eightieth birthday. She is the lady on the front row, fifth from the left. She had been a Sunday school teacher since 1913, and all the ladies were former pupils of hers.

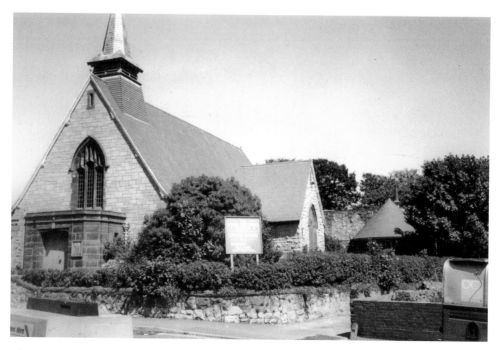

The Old Colwyn Congregational church, designed by Sydney Colwyn Foulkes, had a bustling congregation in the 1950s. In the summer, the Sunday school would invariably end up in Min-y-Don Park next door to the church.

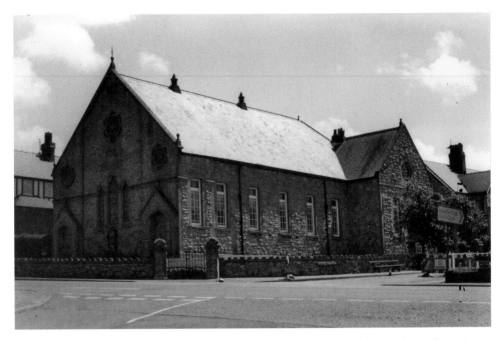

Hebron chapel, on the corner of Bodelwyddan Avenue and Abergele Road in Old Colwyn, was an integral part of the Welsh Christian community in Colwyn Bay. All the associated Welsh chapels were thriving in the 1950s; Bethlehem in Lawson Road, Salem and Tabernacl on Abergele Road, Calfaria and Ebenezer in Old Colwyn, Nazareth in Mochdre, Hermon on Llannerch Road East, Disgwylfa and Bethel at Penmaenhead, Engedi on Woodland Road West and Bethesda on Rhiw Road.

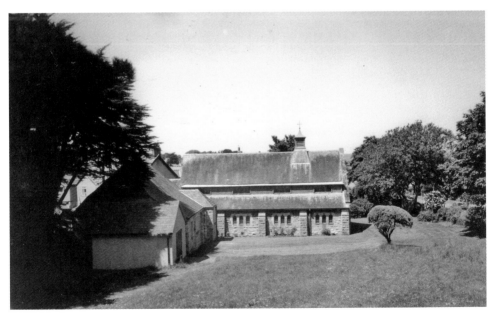

Old Colwyn Methodist church in the 1950s, before the extension was added sixty years later.

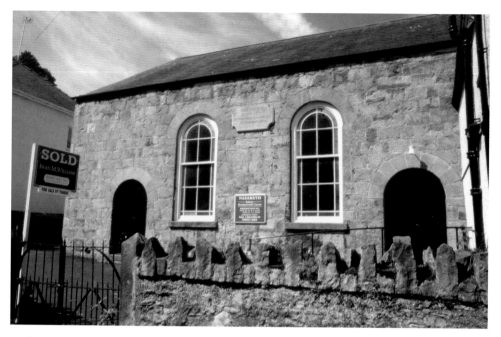

In the 1950s, Nasareth chapel, on Chapel Street in Mochdre, boasted a full congregation; fifty years later, it is no longer a haven for religious services.

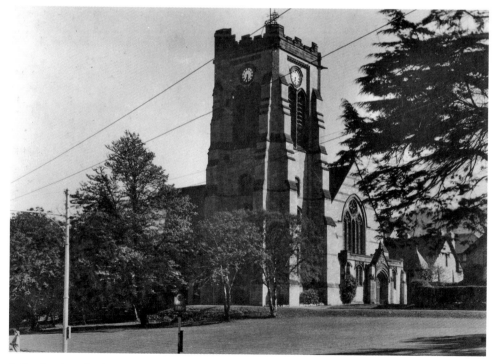

St Paul's church, designed by John Douglas, where Revd Canon Hugh Rees presided for the entire decade. The tram wires can be seen dangling across the top of the picture.

11

THE '50S SHOPPING
EXPERIENCE

Station Road was the shopping mecca of North Wales during the 1950s. All the
fashionable shops were located there. W. S. Wood's, Daniel Allen & Sons', Neville &
Co., Anstiss Ltd, who advertised as 'The Store With The Obliging Staff', and Rhydwen
Jones and Davies department stores; W. Jones the jewellers, A. S. Nevatt the outfitter,
J. Wallis the boot and shoe shop; Harry Pinnington's Cartmell Hotel and Rosie
Davies the furriers. People seeking elegance and quality flocked from far and wide to
make their purchases along this road, but, by the late 1950s, people were beginning
to shop elsewhere as other towns recovered from the war, and the goods being sold
in Colwyn Bay became expensive compared to those being sold in the new shops in
other towns. At the end of the decade, three architects, Sir Clough Williams Ellis, who
created Portmeirion, Leonard Moseley and Stuart Powell Bowen planned a £7,000
rescue along the same lines as the 1958 coordinated facelift that had given new life
to Norwich's Magdalen Street. Sadly, nothing became of the Colwyn Bay architects'
proposals, except for the removal of an interesting and historic drinking fountain and
gas lamp standard at the top of the road.

The Colwyn Bay and District Co-operative Society Ltd was a bustling community
business in the 1950s. Indeed, this was probably the decade in which the stores were at
their most profitable. There was a store in Old Colwyn on Abergele Road and a larger
one on Sea View Road, Colwyn Bay. The business traded on the habits picked up during
the war, when everyone felt that 'they were in it together' and when everyone felt that
they were 'pulling together'. It was a matter of pride to collect your 'divvy' (dividend) by
shopping at the Co-op. These shops still used the system of payment whereby, when you
handed over your cash for the purchase you had made, the cash was placed in a small
metal container which was attached to an overhead line; the shop assistant then yanked a
cord which made the canister fly across the ceiling to the cashier's little office cubicle. The
cashier would take out the money, insert the change and receipt, and reverse the process.

There were, of course, plenty of smaller businesses which had been able to thrive
during the war due to the patronage of the many Ministry of Food civil servants, which

continued their success into the 1950s. W. J. Pender the furniture and antique dealer, in a shop that could have doubled as a peculiar set in a sinister Alfred Hitchcock film, was trading in Woodland Road West. Stonier & Co. Ltd, the glass and china merchants, were selling their wares in Station Road. A. Jenkinson & Sons, the 'Seedsmen, Florists, Fruiterers' shop was doing a roaring trade from No. 58 Abergele Road and Mr Cubbon, the builder and contractor from Erw Wen Road, who had done a lot of work for the Ministry of Food, was still working at full-tilt. In the fifties, Woolworths, on the corner of Abergele Road and Woodland Road East, was one of the first shops to become a self-service store. Daphne Evans, a young girl from Bagillt, thought it very funny when her small packet of chewing gum kept falling through the lattice work of the store's baskets. Every store was, of course, wreathed in the tangy smell and cloudy vapour of cigarette smoke.

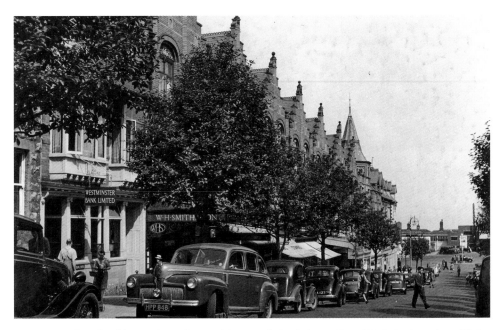

Station Road in the fifties, where the wealthy people in Colwyn Bay did their shopping. All the best shops were located here. All the buildings on this side of the road were designed and built together on fields, between the Central Public House at the top and the Imperial Hotel at the bottom; they included the first police station and the first post office. Both buildings still have visible clues as to their original use.

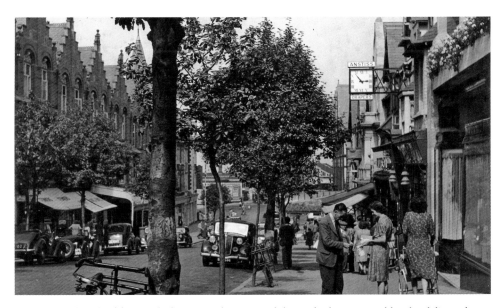

Station Road in the fifties with the Maypole grocers' bikes, which were used by the delivery boys, propped beside the trees and the clock above Anstiss, the drapers, proving that this photograph was taken in the afternoon. W. S. Wood's department store is on the immediate right, and one of the stone figures can be seen standing on the pediment among the flower display. The individual buildings on the right were built willy-nilly, designed separately, and give the whole façade an appealing quirkiness.

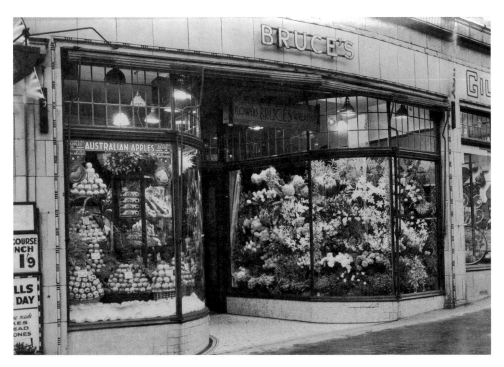

The long-established florists and fruiterers, Bruce's, on Penrhyn Road, in 1955. It was run by Mrs Bruce and her son, Dennis, who, his mother made sure, remained a bachelor to the end of his days. To the left you can just see the sign advertising a two course lunch for 1s 9d outside the Lantern Café, which was up some narrow stairs on the first floor. One of the mainstays of Bruce's business was the weekly supply of fruit to the pupils of the two boarding schools in the town, Rydal and Penrhos.

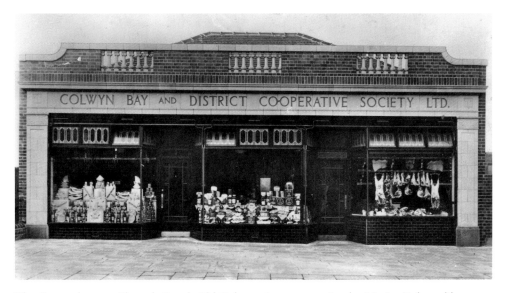

The Co-op shop on Abergele Road, Old Colwyn. It was opposite the Marine Pub, and has now been demolished.

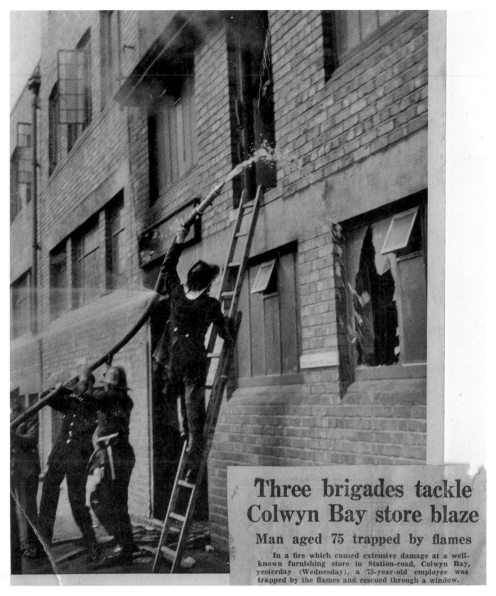

Three brigades tackle Colwyn Bay store blaze
Man aged 75 trapped by flames

In a fire which caused extensive damage at a well-known furnishing store in Station-road, Colwyn Bay, yesterday (Wednesday), a 75-year-old employee was trapped by the flames and rescued through a window.

On Wednesday morning, 23 May 1956, a fire broke out in one of the most prestigious shops in town, Daniel Allen & Sons. The fire brigade was a Fred Carno's outfit compared to today's organisation, and the man who was trapped in the building was an employee aged seventy-five, emphasising the need, in the 1950s, for some people to keep working well after retirement age.

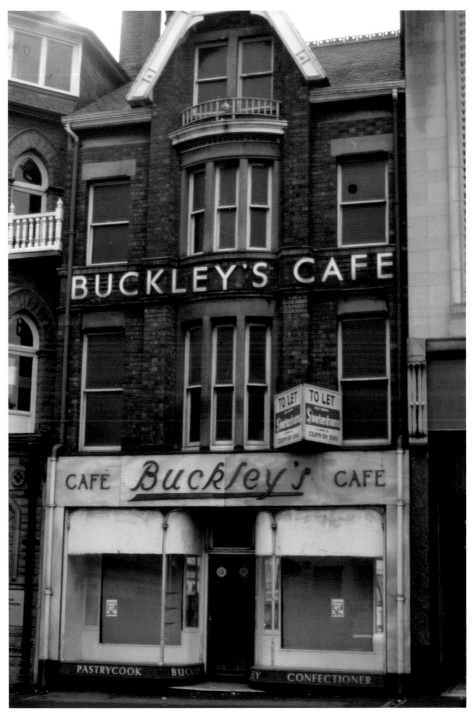

Most shoppers took a break from this arduous task by having morning coffee, or lunch or tea in Buckley's Café. In the 1950s, it was the premier meeting place and watering hole in Colwyn Bay. All the cakes on sale were made on the premises, and the whole business was run by Dick Moore, who was an outstanding and nationally known cricketer.

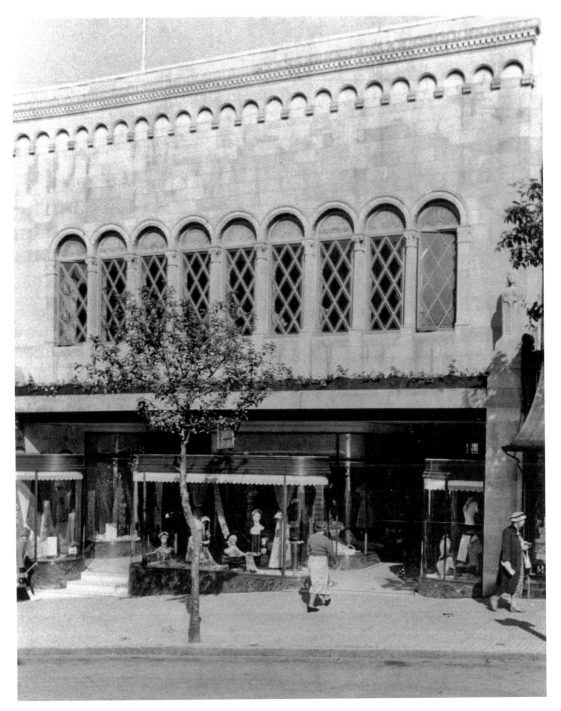

W. S. Wood's department store at the top end of Station Road, along with Daniel Allen's, was where many people did all their shopping.

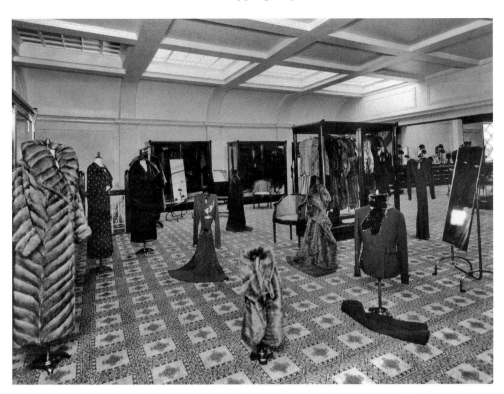

The two interior pictures show the fur department and the hat department in W. S. Wood's department store.

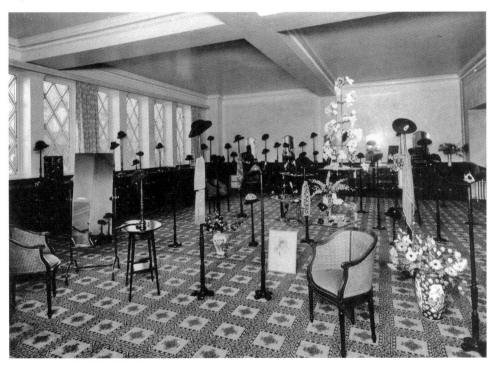

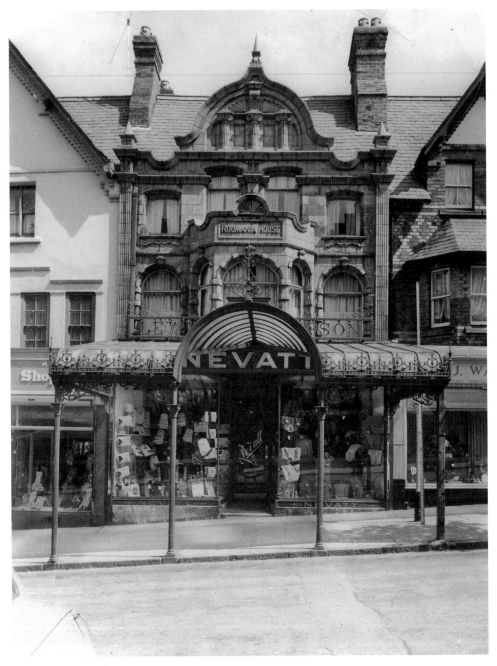

A. S. Nevatt's the outfitters, a 'superior' shop in Roumania House, Station Road.

12

THE SWIMMING POOL

In the 1950s, the outdoor swimming pool at Rhos-on-Sea was part and parcel of the social life of the area. Young people went not only to swim but to meet their friends and have an enjoyable time. There was a children's paddling pool, high diving boards, a slide, a small shop, swimming galas, beauty contests and a café with a flat concrete roof where the youngsters would disport themselves, lying on their towels in the sunshine.

The water for the pool was pumped in from the sea, under the promenade and the Rhos Abbey Hotel, then purified and pumped back out to the sea. In the advertisement for the pool there was a line, '400,000 Gallons Of Crystal Clear Sparkling Sea Water. Sterilized in Accordance to the Ministry of Health.' Matthew Breese was the manager from the moment the pool was opened in 1933 until late into the 1960s. But the 1950s were the high-days of the life of the pool, and Mr Breese was a highly efficient and benevolent manager. From 1 p.m. to 2 p.m., everyone had to get out of the water while he had his lunch, as he was also the lifeguard, and everyone obeyed the rule. The pool closed at 9 p.m., a time which he registered by ringing a large school-like hand bell. He also had a parrot, called Coko, who would mimic the bell and squawk 'all out' in Mr Breese's voice.

The swimming pool was dug and constructed in 1933, as shown in the photograph, and was opened on 28 July of the same year by Jack Petersen, then the heavyweight boxing champion of Great Britain. In the picture, Penrhyn Avenue is in the background and the sea is through the trees on the left.

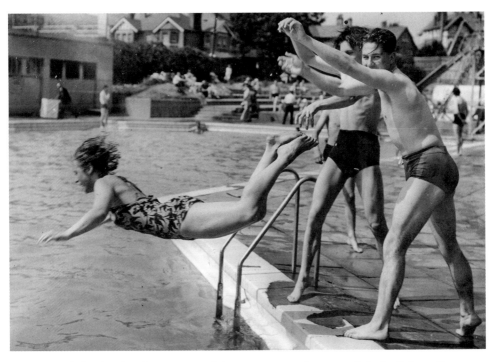

Young people having fun. It was unusual for teenagers and young adults in Colwyn Bay to go into pubs in the fifties, but they would line up in an orderly fashion on the first day the pool opened each year in order to get their season tickets. There was much kudos to be won by buying ticket number one.

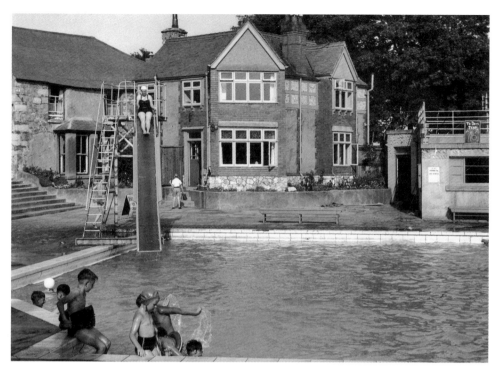

The slide, with Mr Breeze's home in the background and the present Rhos Fynach pub to the left. Mr Breeze was the pool manager; his word was law and he was obeyed.

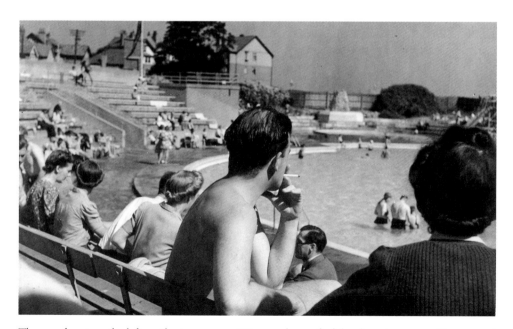

The people sat on the left on the terrace are sitting on the roof of the changing rooms. You entered via the entrance in the background, boys to the left and girls to the right. Some brave, cocky lads would always turn to the right, laughingly declaring that they had forgotten which way was which.

POOL CHARGES

BATHING
ADULTS 2/- JUNIORS 1/- SPECTATORS 1/-

GALAS & SHOWS
ADULTS 1/6 JUNIORS 1/-

SEASON TICKETS
ADULTS £1·5·0 JUNIORS £1·0·0

HIRE OF
SWIM SUIT 6ᵈ (10/- DEPOSIT) TOWEL 6ᵈ (2/6 DEPOSIT) BATHING CAP 6ᵈ (2/6 DEPOSIT)

TABLE TENNIS 6ᵈ each per half hour (2/6 DEPOSIT)

OPEN DAILY 10 A.M.

All Children to be paid for • Dogs 6ᵈ admitted if on leash
• Deck Chairs may be had from Gents. dressingrooms

CAFE Children's PLAYGROUND FREE CAR PARK

The 1955 charges.

13

From the Old to the New

The 1950s were watershed years for Colwyn Bay; the people with land and money passed away, the middle class discovered that they had increasing money to play with, but not enough to splash out on fancy houses and luxury goods, and the poorer people of the area found that there was new work, which allowed them to live without worry. Thus it was that the 1950s saw the dissolution of the larger homes, and the transformation of many of them from houses into institutional units. This trend was exacerbated by the war years, when the large houses were taken over by the Ministry of Food, and when the original owners realised after the war that they could no longer maintain them as once they could. Bryn Teg, on Tan-y-Bryn Road, which had been used during the war as an officer's mess, was converted into three houses and the land was given over for ten bungalows; Bryn Dinarth, Mr Horton's former home, was demolished and replaced by flats and dozens of bungalows built on the extensive land. The name, Horton Drive, is the last clue to the land's former ownership. Pwllycrochan Hotel, which had originally been Erskine House, the home of Sir David Erskine, became home to a school in 1953 and the Colwyn Foulkes architect practice was commissioned to re-jig and refurbish the interior to accommodate 200 schoolboys. When Ralph Colwyn Foulkes informed the owner of the Colwyn Bay Hotel, Ambrose Quellyn Roberts, that the Pwllycrochan Hotel had been sold to a school, thinking that he would be delighted, he was told in no uncertain terms that it was awful news; Roberts thundered, 'We must all have competition, especially good quality competition.' The large houses on Llysfaen Road, Langside and Tirionfa, came tumbling down to make way for private housing developments. Socially and economically, the 1950s, though little understood and little realised at the time, were years in which the fabric of Colwyn Bay changed dramatically.

Highlea, Ebberston Road West, was a home in the 1950s but has now gone and has been replaced with a housing estate.

Tan-y-Bryn hotel, originally built as a home, was a thriving holiday destination in the fifties when Mr Towne was the owner. It has now gone, and has been replaced by houses.

In the 1950s, Bod Euryn was a huge family home with its own allotments along Tan-y-Bryn Road, tended by Mr Price. It was taken over by the local authority and used as a care home, and is now a private nursing home.

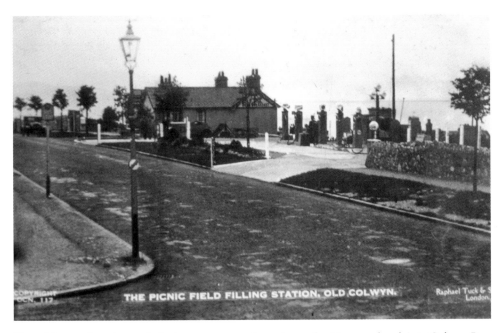

Knowle's petrol station and picnic area was on the main road at Penmaenhead, into Colwyn Bay, in the 1950s. It was demolished to make way for a large well-appointed housing estate.

East Parade, showing the Belvedere Hotel in 1959. Pendorlan secondary modern school and the Wireless College were at the far end of the road, and the railway line is to the left. Also on the left were the wartime allotments, in which the local men had toiled during the conflict urged on by Lord Woolton, the Minister of Food. All these building have now been demolished and replaced by the A55.

Rhuallt Farm on the corner of Llysfaen Road and Peulwys Road, Old Colwyn. It was still going strong in the 1950s, but was subsequently pulled down to make way for a well-appointed modern home.

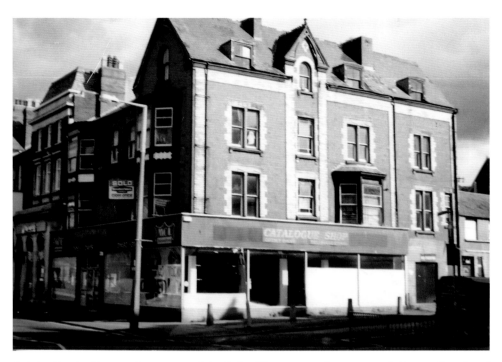

Originally the Regent Store, owned by John Homan ,on the corner of Conwy Road and
Llewelyn Road, which was fully occupied and survived in the fifties by selling tat. It has now
been demolished and replaced by a building that houses the Probation Service.

14

A TIME OF DEPARTURE

Never look back; it is not the way we are going. We are all of us, to a certain extent, however, continually looking over our shoulders to a time when we think the small world we knew was in some ways better than our present surroundings. The fifties was a time when, in Colwyn Bay, in the Pier Pavilion and the cinemas, the songs of the shows – *Oklahoma, Guys and Dolls, The Pajama Game* – were part of the currency of popular culture; that all vanished in the following decade with the advent of rock 'n' roll. When my father shouted upstairs to me, on the morning of 2 June 1953, that Mount Everest had been climbed by Edmund Hilary and Sherpa Tenzing, it was exciting and exhilarating. Sixty-one years later, Tenzing's son, Norbu, said, 'People of that generation climbed with the simple hope of going on an adventure, of doing something no one had done before. Everybody was working together and the sense of comradeship was unique.' He felt that his father, who died in 1986, would be saddened today if he were alive to witness the 'charade' that climbing Everest had become. Roger Bannister was a twenty-five-year-old aspiring doctor, who trained with his friends and ran on a clinker-covered track at Iffley Road, Oxford, when he ran a mile in under four minutes in May 1954; now the whole athletic experience is an international and political rigmarole.

The peaceful certainties of the fifties gave way to the worries and fear of the sixties, generated in good measure by the Vietnam War. Teetering on the coast of Wales, Colwyn Bay was untouched by the tragedies of the Korean War, and the barbarities inflicted on the other side of the world at the beginning of the fifties, or by the two nuclear bomb tests, which took place in the Nevada desert in January 1951. The defection of the spies, Donald MacLean and Guy Burgess, to Russia in June 1951 was met with mild amusement and a great deal of enjoyment by the housewives of Park Road and the old comrades in the men-only British Legion Club on Coed Pella Road.

The borough librarian, Ivor Davies, loved to tell funny stories to visitors to his office. 'Geoffrey,' he would say to the town clerk, 'have I told you the story of the Scotsman, the Irishman and the Englishman? Oh yes, there's a tick against your name.' He had a little black book of funny stories, and against your name he put a tick when he had told it to you. The officials in the town had fought in some military capacity during the Second World War and were understanding,

unflustered, hard-working, reliable and honest. Archie Woodiwiss, a teacher of short-hand and a council committee clerk, was always on hand to encourage young aspiring reporters; Trevor Williams, the *North Wales Weekly News* reporter, used to lubricate his typewriter ribbon with the ash that dropped from his cigarettes; Harry Pinnington, the chairman of the bench, broached no arguments. Police Superintendent Owen Jones and his wife lived on the premises of the police station, on Rhiw Road, and Mrs Jones cooked the most nutritious and succulent meals the prisoners had ever tasted. Mr Joffre Cull (Rikki), the local photographer, attended a dinner at Rhos Abbey Hotel and afterwards, while driving home in the dark along the promenade, the door fell off his Morris Minor car, an event which made the young reporter Derek Bellis, who was a passenger in the car and had had a few too many ciders, think that he was hallucinating. Harry Salt was a councillor who always wore a heavy overcoat, with a belt, which nearly touched the ground; one day in the town clerk's office, they had a party to celebrate the silver jubilee of Harry Salt's overcoat. Cllr Percy Cawthray was a shoe repairer who owned a shop in Sea View Road; when he was chairman of planning on the council he and the town clerk, Geoffrey Edwards, used to go to conferences together to places like Brighton. Geoffrey Edwards used to find the nearest pub to their hotel, leave Mr Cawthray there, and pick him up at 1 p.m. The fifties – truly a bygone age.

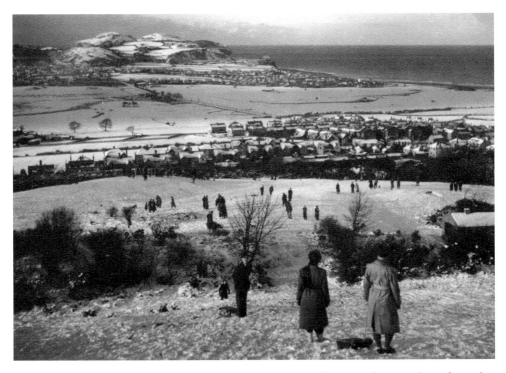

A carefree day in January 1952, when the tobogganers built a very fast run down from the summit of Bryn Euryn. The view shows Dinerth Road in the foreground, and the Little Orme in the background.

BIBLIOGRAPHY

Dorken, Revd Francis C., *Rhos-on-Sea Congregational Church-Souvenir Handbook of Golden Jubilee Celebrations* (Hirst, Kidd & Rennie Ltd, Oldham, 1957).

Easdown, Martin and Thomas Darlah, *Piers of Wales* (Amberley, 2010).

Edwards, Geoffrey, *The Borough of Colwyn Bay 1934–1974* (Colwyn Borough Council, 1984).

Evans, Gillian, *The Coleg Llandrillo Cymru Story* (Nereus, Bala, 2011).

Jones, L. Rhiannon, Nancy Jones and Jean Sockett, *Ysgol Bod Alaw, Bae Colwyn 1950–2000* (Deuparth Gwaith ei Ddechrau, 2000).

Leigh, Revd Brenda, *Old Colwyn Methodist Church 1909–2009* (Handy-Office, 2009).

Lingard, Brian, *Special Houses for Special People* (The Memoir Club, 2005).

Lingard, Brian, *All the Rest of the Bricks and Mortar* (The Memoir Club, 2014).

Mellor, George E., *Colwyn Bay Cricket Club – Founded 1923* (Colwyn Bay Cricket Club, 1992).

Minutes of the Borough of Colwyn Bay Council: 9 Volumes 1950–59 (Colwyn Bay Borough Council, copies held in Colwyn Bay Library).

Slattery, Patrick, *Around Old Colwyn* (Tempus, 2007).

The Congregation: English Baptist Church, A Short History 1885–2005 (Privately Printed, 2005).

Thomas, Dilys, *Memories of Old Colwyn* (Bridge Books, 2000).

Vaizey, Hester, *Keep Britain Tidy & Other Posters From the Nanny State* (Thames & Hudson, 2014).

Williams, S. P., *Mochdre Cricket Club 1948–1988* (Colwyn Duplicating Services Ltd, 1988).

THANKS

I wish to thank the following people for their generous help and encouragement: Revd Patrick Slattery, Eunice Roberts, Tom Wyatt, Ralph and Elizabeth Colwyn Foulkes, Donald Gorst, Roger Taylor, Terry Deakin, Joan Sattler (née Bellis) and her young brother Derek, Revd John Evans and David Coathup, and my primary school teacher, Les Blease.

GRAHAM ROBERTS

COLWYN BAY

THROUGH TIME

Colwyn Bay Through Time

Graham Roberts

This fascinating selection of photographs traces some of the many
ways in which Colwyn Bay has changed and developed over the last
century.

978 1 84868 677 9
96 pages, full colour

Colwyn Bay Folk

Graham Roberts

A fascinating look at the people and personalities who influenced the
history of this picturesque town in North Wales.

978 1 4456 3309 1
128 pages